PHOTOSHOP TRICKS
for DESIGNERS

HOW TO CREATE

BADASS
EFFECTS
IN PHOTOSHOP!

A Corey Barker
Book

The **Photoshop Tricks for Designers** Book Team

Managing Editor
Kim Doty

Technical Editor
Cindy Snyder

Art Director
Jessica Maldonado

PUBLISHED BY

Peachpit Press

©2016 Kelby Corporate Management, Inc.

Trademarks

All terms mentioned in this book that are known to be trademarks or service marks have been appropriately capitalized. Peachpit Press cannot attest to the accuracy of this information. Use of a term in the book should not be regarded as affecting the validity of any trademark or service mark.

Photoshop is a registered trademark of Adobe Systems Incorporated.

Warning and Disclaimer

This book is designed to provide information about designing in Adobe Photoshop. Every effort has been made to make this book as complete and as accurate as possible, but no warranty of fitness is implied.

The information is provided on an as-is basis. The author and Peachpit shall have neither the liability nor responsibility to any person or entity with respect to any loss or damages arising from the information contained in this book or from the use of the discs, electronic files, or programs that may accompany it.

THIS PRODUCT IS NOT ENDORSED OR SPONSORED BY ADOBE SYSTEMS INCORPORATED, PUBLISHER OF ADOBE PHOTOSHOP.

ISBN 10: 0-134-38657-4
ISBN 13: 978-0-134-38657-7

1 16

Printed and bound in the United States of America

www.peachpit.com
www.kelbyone.com

Corey Barker

Corey Barker has been a well-known Photoshop instructor for the past 10 years, but has been using Photoshop for the past 20 years. Since version 2.0, Corey has used and mastered every version of Photoshop and continues to inspire through his art and teachings with the latest versions. Corey was attending Ringling College of Art & Design, where he was pursuing a degree in illustration, when in his fourth year, he discovered Photoshop. It was at that moment the craftsman found his tool of choice.

Corey has since gone on to become an award-winning designer and educator in a variety of fields. In 2006, he joined the Photoshop Guys on the popular videocast *Photoshop User TV* and is a regular contributor to *Photoshop User* magazine, where he writes the popular Down & Dirty Tricks column. He is also author of the best-selling books, *Photoshop Down & Dirty Tricks for Designers*, volumes 1 & 2. He teaches at live events, such as the Photoshop World Conference and Adobe MAX, and he taught the Down & Dirty Tricks seminar tour to thousands live all over the country.

Corey was recently inducted into the Photoshop Hall of Fame for his contributions to the education of Photoshop and continues to inspire through his online training, books, articles, and training events. He recently founded PhotoshopMasterFX.com, which is a Photoshop design and effects online training site with inspired imagery and next-level training that helps users get the most they can out of Photoshop and their creative selves.

Learn more and follow Corey online by visiting him at:

His Site: PhotoshopMasterFX.com

Facebook: www.facebook.com/coreyps3D

Instagram: @coreyps3D

Twitter: @coreyps3D

YouTube: www.youtube.com/user/cbarker33

Table of Contents

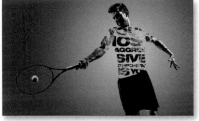

Table of Contents

(1) Who should have this book?

This book was designed to be a quick-access handbook, mainly for working designers and artists, but that doesn't mean that photographers or even hobbyists can't get something out of these pages either. Whether you need quick instruction or even just a little inspiration, this book is for you!

(2) What is the user level of this book?

This book assumes an intermediate or higher-level user—especially later in the book when you get to the Hollywood-style and 3D chapters. But, that does not mean it excludes beginners. The exercises are easy to follow along with for newbies, if you are patient with the steps, but it helps to at least have a good foundation of how Photoshop works.

(3) What about the fonts used in this book?

The fonts used in this book, in many cases, are the default fonts that are part of your OS. However, quite a few are from Adobe Typekit, which is a font service that is part of Adobe's Creative Cloud and allows you to sync fonts to your desktop applications. This service is only available to full Creative Cloud subscribers.

(4) What version of Photoshop do I need for this book?

The exercises in this book were created in Photoshop CC 2015. If you are using an older version of Photoshop, I first have to ask, why? I am kidding. Though, seriously, a lot of the techniques within this book can be done in some older versions of Photoshop, but if you are a Creative Cloud subscriber, you should have the newest version anyway.

(5) What about exercise downloads?

You can follow along with the projects by downloading low-res versions of the same image files used in the book. This way you can make sure you understand the techniques, so you can then apply them to your own projects. You can download these files over at **kelbyone.com/books /psdesignbook**.

(6) How about the use of stock images?

While in some cases I use images I have shot with my camera or my phone, I have always been a big proponent of using stock images. Throughout this book, I utilize a lot of stock images from Adobe Stock (formerly Fotolia.com). This is a fantastic resource and the best part is that it is built right into the Creative Cloud, though it is a separately priced service. When you sign up, you get 10 free images, and you can download watermarked comps of any image.

(7) What about other resources?

In addition to Adobe Stock, there are a few other resources I use that I wanted you to be aware of. While these are not resources I have used in this book, they're ones I do use occasionally and, as a designer, you can never have too much.

PixelSquid.com: The folks at TurboSquid .com have created a resource for 3D objects developed specifically for Photoshop. However, they do not use Photoshop 3D in the normal sense. You use a special plug-in to import the 3D objects into your Photoshop designs. You can control the angle of an object, but only in the plug-in window. As of this writing, this service is free but that may change. It's an impressive resource.

DaFont.com: While Typekit is a robust and user-friendly font library, I will still go to Dafont.com for more stylized and unusual fonts. These fonts are free, but be aware of the usage rights for each font.

Archive3D.net: Photoshop's ability to create 3D objects and effects from scratch is really impressive, but you can also import 3D objects created in other applications. One resource I use is Archive3D.net. They have a lot of cool 3D models that you can import into Photoshop, and they are all free. Be warned though, they don't always work when you import them into Photoshop. In most cases, they work fine but sometimes they come in exploded or missing parts. They can be adjusted, but sometimes they are just hopeless, but that's the risk you take when it's free.

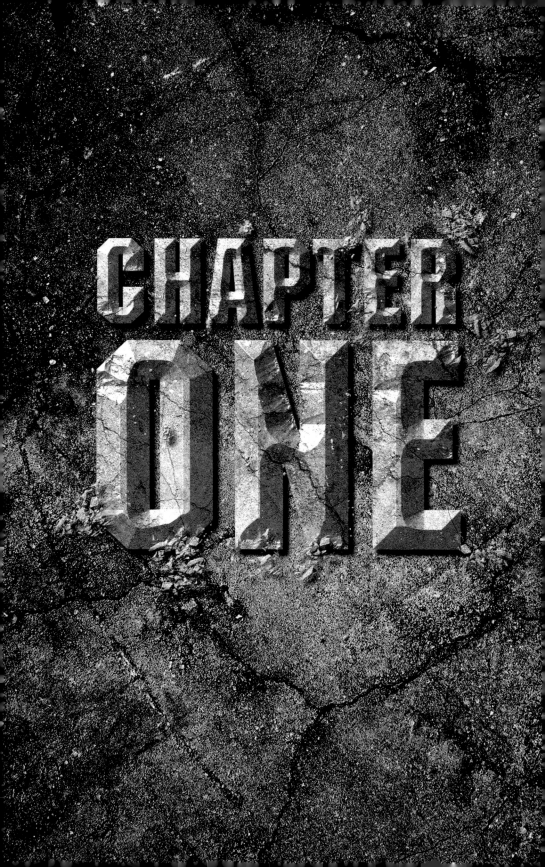

Type Effects

Working with type is an essential skill for a designer, and now Photoshop allows you to do more with type than you ever thought possible. In this chapter, you'll learn a few tricks that will help you think a little more creatively about text as a design element.

This effect was inspired by the movie *Jurassic World*. It's a cool way of using a single texture and layer styles to get an interesting result.

STEP ONE: Start by pressing Command-O (PC: Ctrl-O) and opening the texture image you want to use as your base. You can either use your own or you can download the texture used in this exercise from the book's downloads page, mentioned in the book's introduction.

STEP TWO: Once the file is open, go to the Edit menu and choose Define Pattern. When prompted, give the new pattern a name and click OK.

STEP THREE: Next, press Command-N (PC: Ctrl-N) to create a new document measuring 2000 pixels wide by 1000 pixels tall. Click on the Background Contents color swatch and set the color to Black, then click OK.

STEP FOUR: Now, select the Horizontal Type tool (T), press D, then X to set your Foreground color to white, and click on the canvas to set a new text layer. Choose a thick font in a fairly large size to show as much of the texture as you can. Here, I am using a font called BT Machine. Use the Character panel to adjust the text to your liking (I kerned the second word to match the width of the first).

STEP FIVE: With the text layer selected, click on the Add a Layer Style icon at the bottom of the Layers panel and choose Pattern Overlay. Click on the Pattern thumbnail,

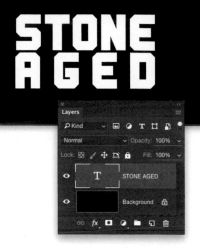

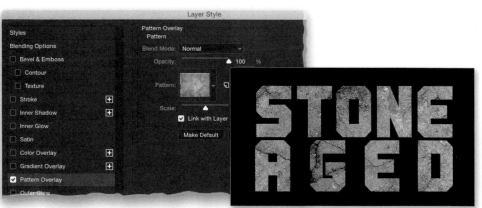

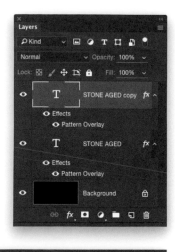

locate the texture you defined in Step Two (it should be the last one), and click on it to select it. Once you select the texture, you can position it in the text manually by clicking on the image and dragging around. Click OK when you're done.

STEP SIX: Make a duplicate of this layer by pressing Command-J (PC: Ctrl-J).

STEP SEVEN: Double-click on the layer style name below this duplicate layer in the Layers panel to reopen the Layer Style dialog, and add a Bevel & Emboss layer style to the existing Pattern Overlay. Use the settings I have here to give the text a chiseled look. Click OK.

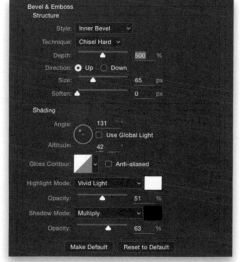

STEP EIGHT: Now, click on the Add Layer Mask icon at the bottom of the Layers panel to add a mask to this duplicate text layer. Then, choose the Brush tool (B) in the Toolbox. In the Brush Picker in the Options Bar, choose a simple spatter brush like the one shown below, which is part of the default brush set. Click the folder icon to the right of the brush thumbnail to open the Brush panel, and under Brush Tip Shape, set the Spacing to around 50%. Turn on the Shape Dynamics checkbox, and set the Size and Roundness Jitters to 0 and the Angle Jitter to 100%. (*Note:* Make sure the Pen Pressure icon in the Options Bar is off, so you control pen pressure in the Brush panel.)

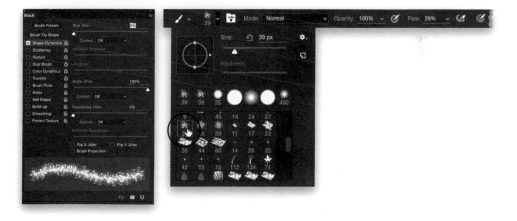

STEP NINE: Make sure your Foreground color is set to black, then with the layer mask active, dab on the image in just a few random areas of the text to get a chiseled look as it redraws the bevel (you're masking away the small areas where you're painting). Be sure not to overdo it.

STEP 10: Next, click on the Create a New Layer icon at the bottom of the Layers panel to create a blank layer above the text layers. Press-and-hold the Option (PC: Alt) key as you click on the *fx* icon on the layer below and drag-and-drop it onto the blank layer above. This will copy the layer style to your blank layer.

STEP 11: Now, using a cool particle brush, we'll add dust and debris falling off the text. We look at creating brush effects in Chapter 5, but you can download these brush presets to use here from the book's downloads page, mentioned in the book's introduction (double-click on the file and it will appear in your Tool Presets panel, as well as your Brush options panel, ready to be used). Just dab around the chipped areas of the text to add the falling particles.

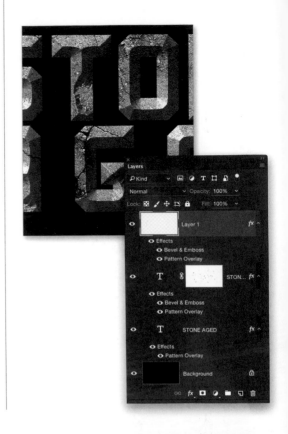

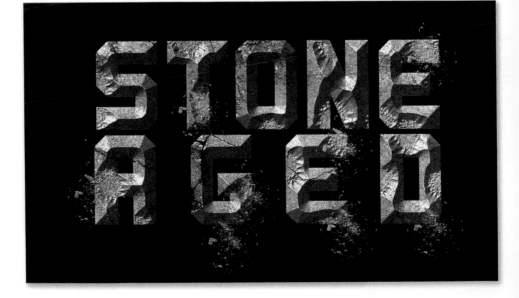

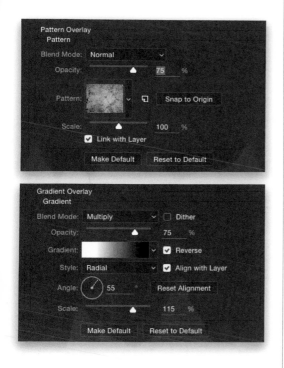

STEP 12: As a final touch, make sure your Foreground color is still set to black and make a duplicate of the Background layer. Then, apply the same stone texture as a Pattern Overlay layer style to this layer for a background element. However, in the Layer Style dialog, drop the Opacity to 75%. Then, click on Gradient Overlay on the left, and set the Blend Mode to Multiply and the Opacity to 75%. Choose the Foreground to Background gradient in the Gradient Picker, set the Style to Radial, and turn on the Reverse checkbox, then increase the Scale to 115%. You can manually position the gradient by clicking-and-dragging directly on the image.

STEP 13: Finally, go back to the original text layer that just has the texture, and apply a Drop Shadow layer style to give it some dimension against the backdrop. As a final option, you can add a Color Overlay layer style to the beveled layer to create more separation, as I did here (I chose an orange color, set the Blend Mode to Overlay, and lowered the Opacity to 50%).

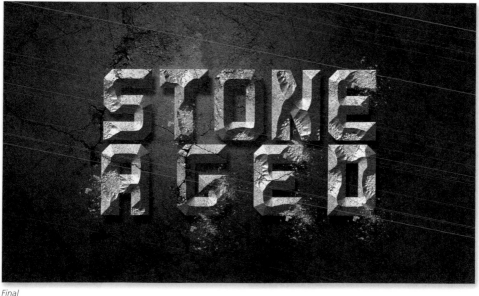

Final

A common design feature these days is a text overlay blended with a background photo in a stylish way. Here we will create a sports-themed poster, but you can theme it to just about anything.

STEP ONE: Press Command-O (PC: Ctrl-O) to start by opening the shot you want to use as your base image. Here, I am going with a sports theme by doing a basketball poster. You can download this file from the book's downloads page, mentioned in the book's introduction, or use any image you want. This technique works on just about anything.

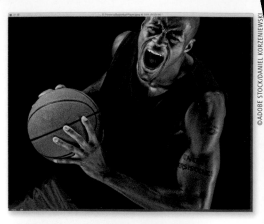

STEP TWO: Press Command-N (PC: Ctrl-N) to open the New dialog, and create a new document that is 1200 pixels wide by 1700 pixels tall, with the Background Contents set to White. Use the Move tool (V) to drag-and-drop the base image onto this new document. Press Command-T (PC: Ctrl-T) to go into Free Transform, and scale and rotate the image into its final position, then press Return (PC: Enter) to commit the changes.

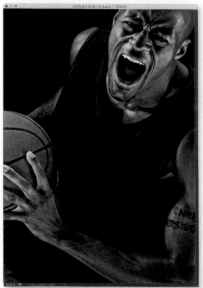

STEP THREE: Now, to a get a quick, gritty look on this sports photo, just make a duplicate of the layer by pressing Command-J (PC: Ctrl-J), then go under the Filter menu, under Other, and choose High Pass. Set the Radius to 10 pixels and click OK.

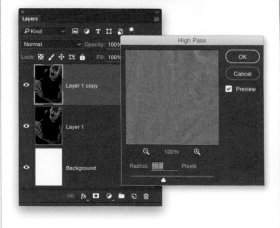

STEP FOUR: Change the blend mode of this high pass layer to Overlay. This will sharpen and enhance the contrast of the subject.

STEP FIVE: Next, we are going to colorize the image using a Black & White adjustment layer. Oh yeah, you heard me right. With the topmost layer selected, click on the Create New Adjustment Layer icon at the bottom of the Layers panel, and choose Black & White.

STEP SIX: In the Properties panel, turn on the Tint checkbox at the top, then click on the swatch to the right to open the Color Picker. Choose a color for the base background and click OK. Here, I am using a gold color (R=174, G=127, B=15). Remember, it is an adjustment layer, so you can change this at any time.

STEP SEVEN: Once you choose the tint color, using the various color sliders below, you can adjust the intensity of the color by color ranges in the image. For instance, increasing the Reds amount will make the shadow areas lighter, thus making the tint color show more. You can continue to adjust the other sliders where needed until the image is to your liking.

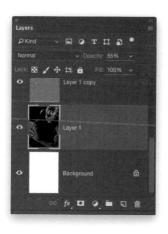

STEP EIGHT: Select the original photo layer in the Layers panel and drop its Opacity to 55%.

STEP NINE: Go under the View menu and choose New Guide Layout. Turn off the Columns checkbox, and turn on the Margin checkbox, then set all sides to 100 px. Click OK.

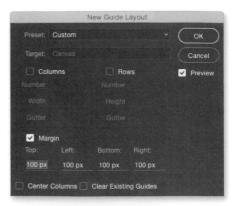

STEP 10: Grab the Horizontal Type tool (T) in the Toolbox. Then, click on the top left margin corner and drag out a text box inside the margin guides. Choose a font in the Options Bar (I used Futura Medium), then set the text to fit the theme. I typed "BAS-KETBALL" but split the word onto three lines, changing the font size and kerning to make it fit evenly, as you see here.

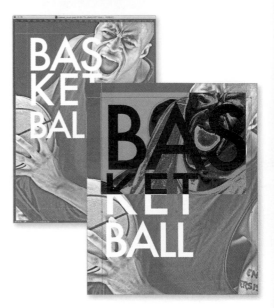

STEP 11: Highlight the first line of text, then press-and-hold Command-Option-Shift (PC: Ctrl-Alt-Shift) and press the period key repeatedly, until the last letter jumps to the next line, then go back one step by pressing the comma key. Do this to the remaining lines to fill the width of the box with the text. Adjust the leading in the Character panel, if necessary (I adjusted it so the lines were close, but not touching).

STEP 12: Double-click the text layer's thumbnail to select the text. Then, go to the Options Bar and click on the color swatch to open the Color Picker. Here, I am using this bright magenta red color since my background is yellow. You may need to experiment with other colors if using a different color background. Click OK when done.

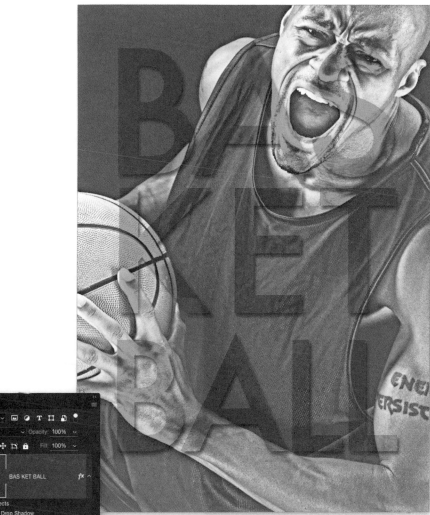

STEP 13: Now just change the text layer's blend mode to Difference, and this will result in an interesting color mix with the background. Finally, as an option, you can add a subtle Drop Shadow layer style to the text layer to create a sense of depth, as you see here. Also, if you change the tint color in the adjustment layer, you will see various interesting results with the way it is all blending.

Here is a rather cool trick for combining styles and textures while still being able to keep all the elements on separate layers. This is yet another reason why mastering layers is key to using Photoshop.

STEP ONE: This effect is similar to the stone texture effect earlier in this chapter but with a little twist to it. It is a pretty cool trick for being able to have complex effects while maintaining full editability of the original text layer. Start by pressing Command-O (PC: Ctrl-O) and opening the texture file you want to use. Here, we have an interesting rust texture.

STEP TWO: Define this texture as a pattern by going under the Edit menu and choosing Define Pattern. Name the texture when prompted. Click OK.

STEP THREE: Press Command-N (PC: Ctrl-N) to create a new document measuring 2000 pixels wide by 1000 pixels tall, with the Background Contents set to Black. Now, select the Horizontal Type tool (T) in the Toolbox, click in your document to set a new text layer, and type some text. Here, I typed a simple, bold, two-word title. Be sure to use a really thick font for this (I used a font called Swiss Black), and use the Character panel to adjust the text to your liking (I kerned it and adjusted the leading).

STEP FOUR: Once the text is set, go to the Layers panel and add a new blank layer above or below the text layer (I added mine below by Command-clicking [PC: Ctrl-clicking] on the Create a New Layer icon at the bottom of the panel).

STEP FIVE: Now, Command-click (PC: Ctrl-click) on both the text layer and the blank layer to select them, and press Command-G (PC: Ctrl-G) to group them in a folder (the layers are still separate, but just nested in this group). The cool thing about this is we can apply a layer style to the group and it will see the layers as one, even though they are separate.

STEP SIX: With the group folder selected, click on the Add a Layer Style icon at the bottom of the Layers panel, and choose Pattern Overlay. Click on the Pattern thumbnail and choose the texture you defined in Step Two (it should be the last one). Remember,

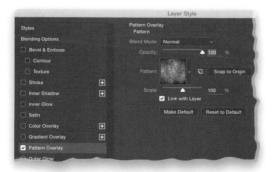

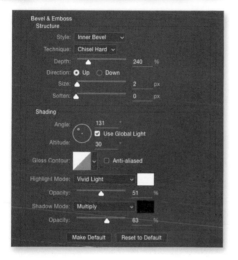

you can adjust the position of the texture manually by clicking-and-dragging directly on the image. Don't click OK yet.

STEP SEVEN: Click on Bevel & Emboss on the left and use settings similar to what I have below to give the text some dimension on the edges. The bevel will become more pronounced in a minute.

STEP EIGHT: Okay, remember that blank layer? Click on the small arrow to the left of the group folder in the Layers panel to reveal the layers in the group. Then, click on the blank layer to select it.

STEP NINE: Now you just want to introduce some graphic element on this layer and it will blend with the text via the layer style applied to the group. For instance, here I used the Brush tool (B) with a brush made from a splash of water (we look at creating brush effects a couple times in this book, but you can download the brush I used here from the book's companion webpage). If you just dab the brush a couple times around the text, it immediately gives you something interesting. So, press D to set your Foreground color to black, and click a few times around the text. Notice how the texture is revealed where the new elements appear. Doing it this way, you have more control over the placement of the text and other elements because they are still on separate layers; they are just in a group. Cool, huh?

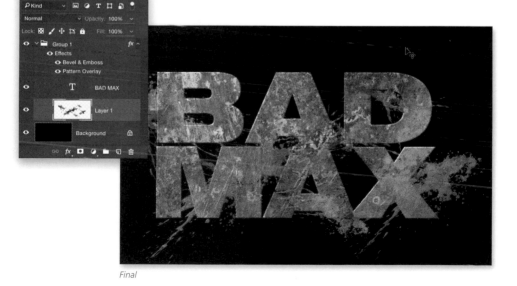

Final

This one I just had to do because it is such a cool effect. I saw it in a sports ad on-line, and it's a very creative way of masking an image inside of text. We'll utilize some handy layer tricks to achieve this effect.

STEP ONE: Start by opening the image of the subject (press Command-O [PC: Ctrl-O]). Here, we're using this tennis player on a white background for easy extraction, which you can download from the book's companion webpage (mentioned in the book's introduction).

STEP TWO: Go to the Channels panel (Window>Channels) and click on the Blue channel to select it, since it has the most contrast. Then, Right-click on it and choose Duplicate Channel from the pop-up menu. Just click OK when the dialog opens.

STEP THREE: Select the duplicate channel and press Shift-Delete (PC: Shift-Backspace) to open the Fill dialog. Set the Contents to Black and the mode to Overlay, and click OK. This will force the subject's gray areas to become blacker and will not affect the white background.

STEP FOUR: There are still some gray areas in the head and arms, so you can apply the Overlay fill one or two more times to make it darker. For some fine-tuning, you can get the Brush tool (B) and use a soft-edged brush with the tool's blend Mode set to Overlay (in the Options Bar) to paint those gray areas to black. You want the subject to be solid black against a white background.

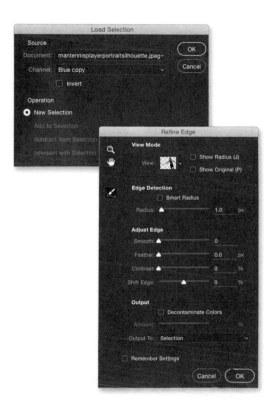

STEP FIVE: Once you have the subject blacked out, press Command-I (PC: Ctrl-I) to invert the image. Now, if you see any light gray areas around the edge, use a simple Levels adjustment to get rid of these (press Command-L [PC: Ctrl-L]).

STEP SIX: Click on the main RGB channel in the Channels panel, and then go to the Select menu and choose Load Selection. Choose Blue copy in the Channel pop-up menu and click OK.

STEP SEVEN: If, at this point, you still need to clean up the selection around the soft edges, you can go under the Select menu and choose Refine Edge to open the Refine Edge dialog. It's not necessary, but it's an option. Once your selection is finished, press Command-J (PC: Ctrl-J) to copy the selected area onto a new layer.

STEP EIGHT: Next, we'll bring this subject into a new document with a background. Here, I used the Move tool (V) to move him onto a background file with a simple color-filled layer with both Pattern and Gradient Overlay layer styles applied.

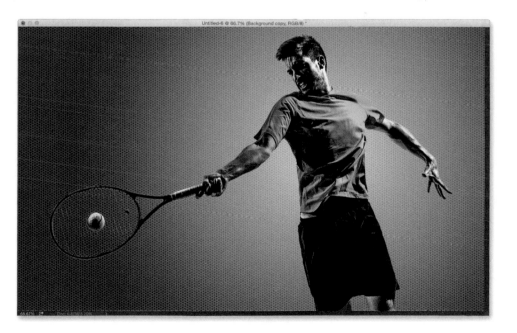

STEP NINE: Now, use the Quick Selection tool (W) to select just the shirt area of our subject. Once it is selected, you can click the Refine Edge button in the Options Bar and use that to adjust the selection, if needed. Sometimes it is just handy to see if the whole thing is selected.

STEP 10: Go under the Select menu, under Modify, and choose Expand. Set the amount to 2 pixels and click OK. This will take care of anti-alias edging that wasn't picked up in the original selection. Then, press Command-Shift-J (PC: Ctrl-Shift-J) to cut the selection out and put it onto a new layer.

STEP 11: Grab the Horizontal Type tool (T) and click on the canvas to set a text layer. You can use a quote, or a group of random words, but it needs to be a bold font (I used the font Swiss721BT Black Extended). Then, you'll need to format each line of the text according to where it falls within the shape of the shirt, since that is our guide. Similar to the way we formatted the text in the image of the basketball player (in the Highlighted Text Overlay technique), we need to make each line readable within the area of the shirt. So, I have a simple quote here that I need to format to different sizes and line positions to fit within the visible area. Also, be aware of the leading. You'll need to keep the space between lines very small, but so the letters are not touching.

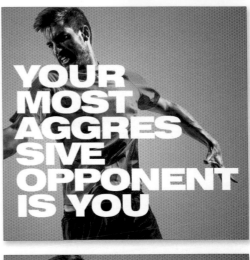

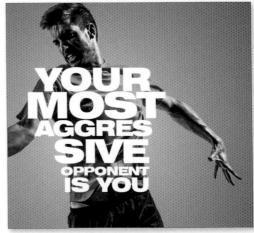

STEP 12: Once you have the text formatted to the shape of his shirt, click on the layer with the shirt and drag it above the text layer in the Layers panel. Press Command-Option-G (PC: Ctrl-Alt-G) to clip the shirt layer inside the text. You'll also see where the text sits inside the shape. Use the same formatting shortcuts to continue to adjust the text to fit in the shape as much as possible, if needed.

STEP 13: Now, even if you get as close as you can, some small parts of the text will still be visible beyond the edge of the subject, so here is a clever fix: Command-click (PC: Ctrl-click) on the thumbnail of the shirt layer to load it as a selection. Then, with the text layer selected, click on the Add Layer Mask icon at bottom of Layers panel. This will mask the excess outside of the shirt area and you can still continue to fine-tune the formatting of the text to fit in that area.

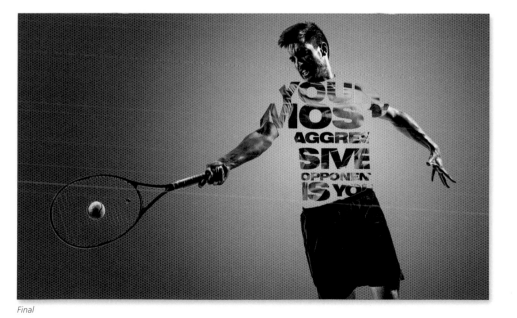

Final

Here is a rather simple, yet cool, 3D trick you can do with text or a photo, just using a couple simple text layers:

STEP ONE: Press Command-N (PC: Ctrl-N) and create a new document with the Background Contents set to black. Now, start by selecting the Horizontal Type tool (T), setting your text color to white (in the Options Bar), and then clicking on the canvas to set a new text layer. Input and format (using the Character panel) your desired text. Just one or two words will do.

STEP TWO: With the text layer selected, go to the 3D menu, under New Mesh from Layer, and choose Postcard. This will place the text layer into its own 3D environment. In the Layers panel, you will see that your text layer has changed into a 3D layer. (*Note:* If this is your first time using 3D, Photoshop will ask if you want to switch to the 3D workspace, which opens the 3D and Properties panels.)

STEP THREE: In the 3D panel, make sure the Current View is selected. Then, in the Properties panel, you will see the camera setting for FOV. Set this number to around 7 mm lens. This will now give you a view of the text as if through a very-wide-angle lens.

STEP FOUR: Use the 3D Mode tools at the right end of the Options Bar to move the text. Use the Slide the 3D Camera tool to

slide the text closer, then use the Orbit the 3D Camera tool to rotate the view angle of the text and you will see the wide-angle effect. This is very handy for getting extreme, but accurate, perspective. Just position the text at the angle you want, then go under the 3D menu and do a quick render when you're done.

To use this layer in another image, simply select the Move tool (V), and drag-and-drop it onto the image, as I have below. Tweak the position with the 3D Mode tools, if needed, then Right-click on the layer and choose Convert to Smart Object. This allows you to work with the 3D layer as if it were a regular smart object, but still allows you to change the 3D aspects of it (just open the original by double-clicking on the smart object thumbnail).

TIP: Remember, it is a 3D layer, so you can go to the Layers panel and double-click on the main Diffuse sublayer to access the original document with the text layer. Just highlight the text and type a new word, then close the document and save the changes. It will update automatically.

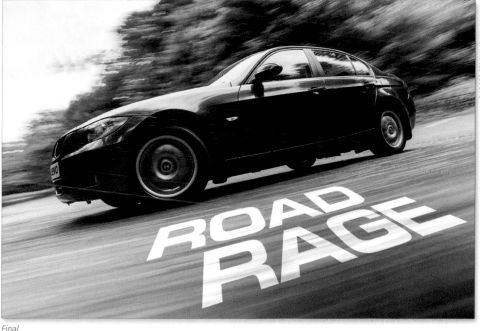

Final

Commercial Effects

In this social media world of short attention spans, it is critical to create commercial design that is eye-catching and impactful in a short time. This chapter explores some ways to use ph otos, textures, graphics, and text in creative ways to grab your audience quickly.

This effect is a cool and stylish way of blending a couple shots of a subject in different scenarios. Here we will take a look at a sports-ad-inspired effect.

STEP ONE: Press Command-O (PC: Ctrl-O) and open the first image that will be used as the base. Here, we're using a baseball player ready at bat.

STEP TWO: Now, open the second image that will be blended with this image. Here, we have the same player, but in this image he is making a diving catch.

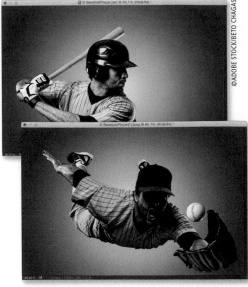

STEP THREE: Once you have the second image open, go under the Edit menu and choose Define Pattern to save the image into Photoshop, because we will be applying the image via a layer style in a little bit. You can name the pattern when prompted.

STEP FOUR: Now, go back to the first image of the ball player. Choose the Rectangle shape tool in the Toolbox (or press Shift-U until you have it), then go up to the Options Bar and set the tool mode (the pop-up menu on the left) to Shape. Set the Fill color to white, or any color you like, and set the Stroke color to none.

STEP FIVE: Start by creating a vertical shape over the image, as shown here. Drawing the first shape will create a new shape layer and fill the shape with the selected color. Click on the Path Operations icon in the Options Bar and choose Combine Shapes.

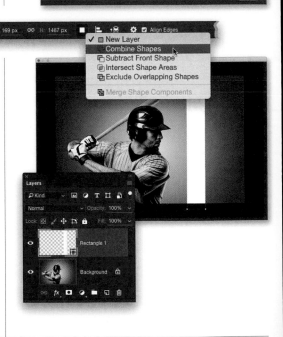

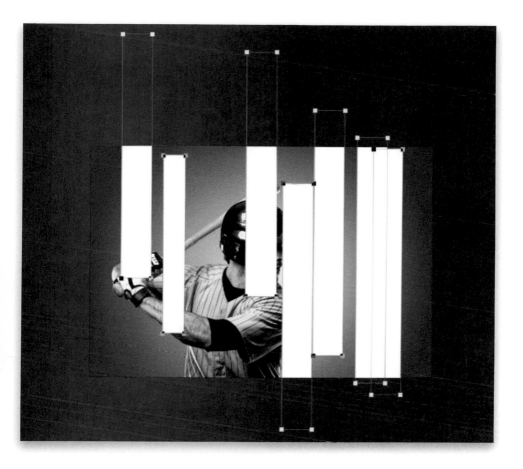

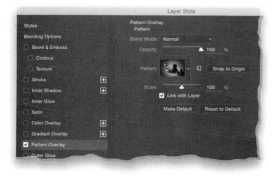

STEP SIX: Then, add another vertical rectangle somewhere else on the canvas. It should add a new shape to the existing shape layer. Continue to add more rectangle shapes until it looks like you see above. We will modify the placement of these in a moment.

STEP SEVEN: Click on the Add a Layer Style icon at the bottom of the Layers panel and choose Pattern Overlay. Click on the Pattern thumbnail and, in the Pattern Picker, locate the image we defined in Step Three (it should be the last one). Make sure the Opacity and Scale are set to 100%. As an option, remember that you can move the pattern image around within the rectangles by clicking directly on that image and dragging it around while the Layer Style dialog is still open. Once you're done, click OK.

STEP EIGHT: With the shape layer selected, go under the Edit menu, under Transform Path, and choose Skew. Then, Option-click (PC: Alt-click) on the top middle control point, and drag to the right to make the rectangles lean to the right. Press Return (PC: Enter) to lock in the change when you're done (click OK in the warning dialog).

In this case, we want to reveal the better parts of each image, so the position of the rectangles must be kept in mind. Remember, you can use the Direct Selection tool, which is the white arrow nested under the Path Selection tool (Shift-A), to modify individual control points or paths to make the rectangles thinner or thicker.

STEP NINE: Once you have the rectangles arranged, you can add more stylized separation from the background by double-clicking on the layer style to reopen the Layer Style dialog and clicking on Drop Shadow on the left, and then use the settings shown here.

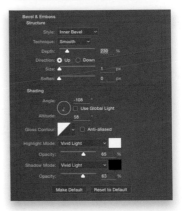

Next, click on Bevel & Emboss, start with the settings below, and tweak them where necessary if using different images.

STEP 10: With the overall effect done, we just need to add some text to finish it up. Here, I am using Eurostile Bold Extended with the title in two colors. So, get the Horizontal Type tool (T), click on the image, and start typing. Highlight each half of the text with the tool and change the color using the color swatch in the Options Bar. Then, add a Drop Shadow Layer style with the Opacity set to around 55%.

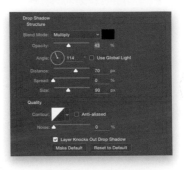

STEP 11: I want the text to be roughly the same angle as the vertical bars. So go under the Edit menu, under Transform, and choose Skew. Option-click-and-hold on the top middle control point again, and drag to the right until the angle is close to that of the rectangles. Press Return (PC: Enter) when done.

STEP 12: As a finishing touch, make a duplicate of this text layer by pressing Command-J (PC: Ctrl-J). In the Layers panel, position this duplicate layer just above the Background layer and below the rectangle shape layer.

STEP 13: Press Command-T (PC: Ctrl-T) to activate Free Transform, then press-and-hold the Shift key as you grab a corner handle and scale the text fairly large. Press Return (PC: Enter) when you're done. Finally, set the layer's blend mode to Overlay and drop the layer's Opacity to around 25%.

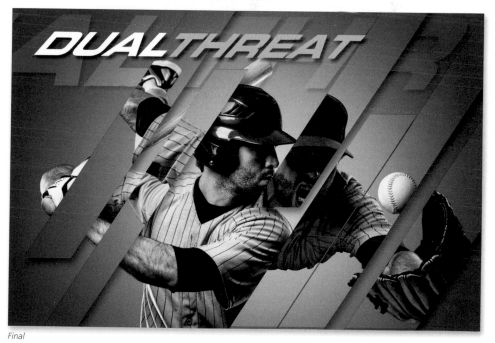

Final

This is another one inspired by a sports ad I saw. It's a good example of using pattern elements, along with various images, to create a composite with really slick commercial appeal.

STEP ONE: Let's start by extracting the main subject, which in this case is this soccer player. I was able to find this one with a white background, so extracting him should be similar to what we did with the tennis player in the Image Inside Text with a Twist technique in Chapter 1. Start by going into the Channels panel and making a duplicate of the Blue channel by Right-clicking on the channel itself and choosing Duplicate Channel.

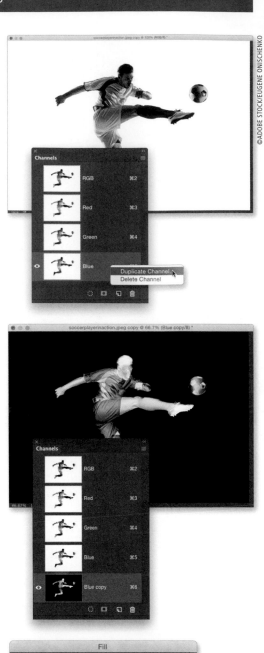

STEP TWO: Once the duplicate channel is made, press Command-I (PC: Ctrl-I) to Invert the channel copy.

STEP THREE: Now, press Shift-Delete (PC: Shift-Backspace) to open the Fill dialog. Set the Contents to White and the Mode to Overlay. Click OK. This will force most gray areas to white and leave the black areas alone. Do this a second time to fill in the gray even more.

STEP FOUR: If there is still some gray area that needs to be forced to white, doing a global fill might overdo it in some areas. So instead, grab the Brush tool (B), then in the Options Bar, choose a soft-edged round brush in the Brush Picker, set the tool's blend Mode to Overlay, and paint with white in the gray areas until the channel is black and white, with no gray.

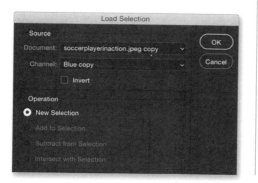

STEP FIVE: With this channel copy prepared, go back to the color image by clicking on the RGB channel at the top. Then, go to the Select menu, choose Load Selection, and choose the Blue copy channel from the Channel pop-up menu. At this point, you can use the Refine Edge dialog (also found under the Select menu) to clean up the selection, if needed. When done, copy the selected area to a new layer by pressing Command-J (PC: Ctrl-J).

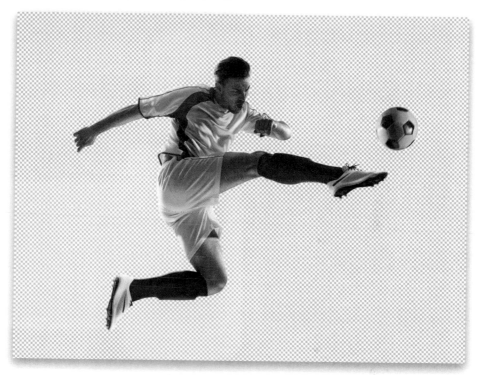

STEP SIX: With the subject extracted, press Command-S (PC: Ctrl-S) to save this document, and then Command-N (PC: Ctrl-N) to create a new one measuring 250 pixels by 250 pixels, with a black Background layer.

STEP SEVEN: Zoom in to about 300%, so you can see what you're doing, then press Command-R to activate the document rulers. Drag out a vertical and horizontal guide from the rulers to the center of the canvas. It should snap to the center for both (unless you have turned this off in the View menu).

STEP EIGHT: Select the Line tool in the Tool-box (it's nested with the shape tools) or press Shift-U until you have it. At the left end of the Options Bar, set the tool mode to Shape. Then, set the Fill color to white, the Stroke color to none, and the line width to 3 pt. Finally, click on the Path Operations icon (just to the right of the Height field), and choose Combine Shapes.

STEP NINE: Starting at the top center, press-and-hold the Shift key and draw a line straight down along the vertical guide. Keep the Shift key held down, and draw a horizontal line along the horizontal guide.

STEP 10: Do the same thing again, except start in the upper-left and then upper-right corners and Shift-click-and-drag lines at 45-degree angles, from corner to corner.

STEP 11: Click on the Create a New Layer icon at the bottom of the Layers panel to create a new blank layer, and press Command-A (PC: Ctrl-A) to Select All. Then, go under the Edit menu and choose Stroke. Set the Width to 5 pixels, the Location to Inside, and the Color to white, and click OK.

STEP 12: Turn off the Background layer's Eye icon, then go under the Edit menu and choose Define Pattern. Name the pattern when prompted.

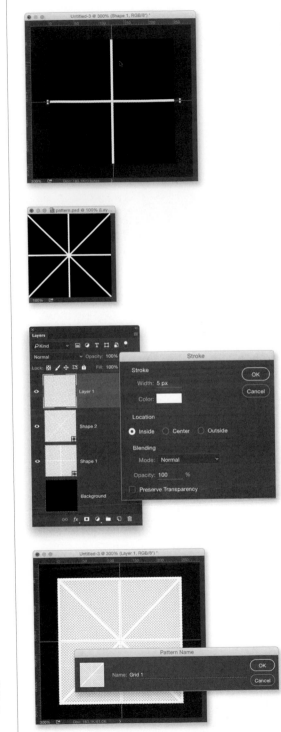

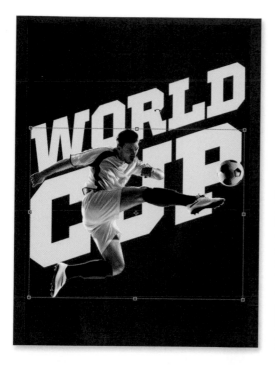

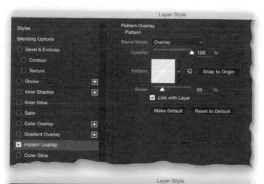

STEP 13: Now, create a new document to build the final design in, measuring 1450 pixels wide by 2100 pixels tall. Set the Background Contents to a dark blue color. (*Note:* I am basing my colors on the colors our subject [the soccer player] is wearing.)

STEP 14: Next, grab the Horizontal Type tool (T) and click in the document to set a new text layer. The text will be a big part of the background, so choose a bold font and a color that will stand out from the background. Here, I am using a font called Old School United Regular, and I chose yellow to match our subject's shoes. I skewed this text similar to the way we skewed the text in the last tutorial to get a dramatic angle (go under the Edit menu, under Transform, and choose Skew), but this time, grab the top-right corner handle and drag upward. You can use the Character panel to adjust the tracking and leading, as needed.

STEP 15: Use the Move tool (V) to drag-and-drop the extracted subject layer onto the main design. Make sure to position it at the top of the layer stack in the Layers panel, so it is above the text. Also, press Command-T (PC: Ctrl-T) to go into Free Transform to scale our subject to fit in the composition (press-and-hold the Shift key while you click-and-drag a corner point to keep him proportional).

STEP 16: Click on the Background layer in the Layers panel, and then add a new blank layer above it. You want to make sure the layer is above the Background layer, but below the text layer. Press Shift-Delete (PC: Shift-Backspace) to open the Fill dialog, set the Contents to 50% Gray, and click OK.

STEP 17: With this gray layer active, click on the Add a Layer Style icon at the bottom of the Layers panel and choose Pattern Overlay. Click on the Pattern thumbnail to open the Pattern Picker and choose the pattern we defined earlier (it should be the last one). Then, set the Blend Mode to Overlay and the Scale to around 50%. Next, go to Blending Options near the top of the list on the left and click on it. In the Advanced Blending section, drop the Fill Opacity to 0. This will allow the pattern to blend with the background. Click OK.

STEP 18: Now, click on the Add Layer Mask icon at the bottom of the Layers panel to add a layer mask to this pattern layer. Then, get the Gradient tool (G), and in the Options Bar, click on the gradient thumbnail and choose the Foreground to Transparent in the Gradient Picker, and click on the Radial Gradient icon (the second icon to the right of the gradient thumbnail). Click-and-drag to add a few gradients to the mask to fade the pattern randomly.

STEP 19: Open the image of the stadium background (you can download it from the book's downloads page, mentioned in the book's introduction). Drag-and-drop it onto the main design, then use Free Transform to scale and rotate it, so that the horizon line of the photo matches the angle of the text. Position it above the pattern layer in the Layers panel.

STEP 20: Finally, add a layer mask to this layer and use the same radial gradient to add some fades to the top and bottom edges of the stadium layer.

BONUS TIP: You can add a little extra blending to the text by selecting the text layer, then clicking on the Add a Layer Style icon, and choosing Blending Options. Then, in the Blend If section, Option-click (PC: Alt-click) on the white Underlying Layer slider knob to split it, and drag the left side to the left a little bit until you see the highlights start to show through. Click OK.

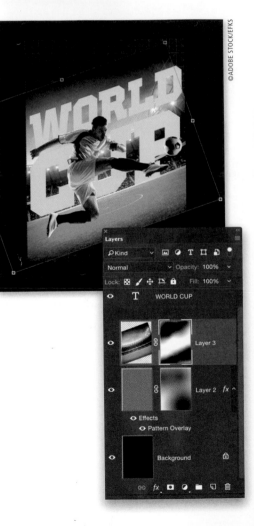

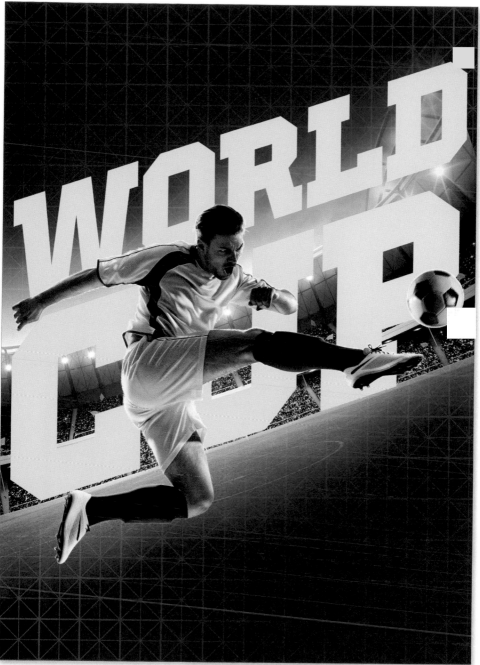

Final

In this exercise, I wanted to show you how Hollywood effects can influence design for commercial products. This compositing technique has been used quite a bit lately in many a movie poster, but since most of us aren't really designing movie posters, here's how to spin the effect to work for a fake whiskey ad.

STEP ONE: Start by pressing Command-N (PC: Ctrl-N) and creating a new document for our final design measuring 1745 pixels wide by 2000 pixels tall. Just set the Background Contents to White for now.

STEP TWO: Next, open a texture to be used as the background. Here, we have a texture from a collection from PhotoArt Textures. Go ahead and use the Move tool (V) to bring this texture into the main document, then use Free Transform (Command-T [PC: Ctrl-T]) to scale and position it to fit in the canvas.

Step 2

STEP THREE: Now open the paint spatter image (download it from the link mentioned in the book's introduction). This will be a framing element for the overall design. However, we need to extract it from the background. This spatter is the wrong color, but that doesn't matter since we just need the shape.

STEP FOUR: Press Command-Shift-U (PC: Ctrl-Shift-U) to remove the color from the image. Then press Shift-Delete (PC: Shift-Backspace) to open the Fill dialog and set the Contents to Black and the blend Mode to Overlay. Click OK. Do this one more time to make the spatter darker.

STEP FIVE: Press Command-I (PC: Ctrl-I) to Invert the image. Then, open the Channels panel and press-and-hold the Command (PC: Ctrl) key as you click on the RGB channel thumbnail. This will load the shape as a selection. In the Layers panel, click on the Create a New Layer icon at the bottom of the Layers panel to create a new blank layer, press D to set your Foreground color to black, and then press Option-Delete (PC: Alt-Backspace) to fill the selection with your Foreground color.

Step 3

Step 4

Step 5

Press Command-D (PC: Ctrl-D) to Deselect, and then use the Move tool (V) to drag-and-drop this spatter element layer onto the main document.

STEP SIX: Once the spatter is in place over the texture, open the image of the whiskey bottle and glass. Drag-and-drop this image onto the main layout, and then use Free Transform to scale and position it so the bottle and glass are roughly centered in relation to the background spatter.

STEP SEVEN: Click on the Add Layer Mask icon at the bottom of the Layers panel to add a mask to this layer. Then, press G to get the Gradient tool, choose the Foreground to Transparent gradient in the Gradient Picker in the Options Bar, and click on the Radial Gradient icon to the right of the gradient thumbnail. Set your Foreground color to black and click-and-drag out some gradients to fade the edges of the bottle layer. This illustrates how you can sometimes blend images without complicated extraction methods.

Step 7

Step 8

Step 9

Step 10

STEP EIGHT: Now, open the first subject image. Here, on the left, we have a girl in sunglasses, because why not? Like the bottle image, bring this image into the main layout and then scale and position it just above and to the right of the bottle. Then, add a black (Hide All) layer mask by Option-clicking (PC: Alt-clicking) on the Add Layer Mask icon.

STEP NINE: Use the same gradient as in Step Seven, but set your Foreground color to white instead of black, and add a gradient in the area of the subject's face. Add multiple smaller gradients to reveal more of the subject, where needed. Now you can see it coming together.

STEP 10: Do the same thing with the second subject, the guy in sunglasses. Why? Because! Go ahead and drag-and-drop him onto the main image and position him above and to the left of the bottle. Then, add a black layer mask and reveal him with a white radial gradient like before.

STEP 11: Now, as a result, I can see we need to add a couple abstract elements to the sides to help with the blending of the subjects. Here, I have a rather interesting collection of particle elements that will work nicely.

STEP 12: Since these are white on black, all you need to do is press Shift-Delete (PC: Shift-Backspace) to open the Fill dialog, set the Contents to White and the blend Mode to Overlay, and click OK to make them brighter.

STEP 13: Next, go to the Channels panel and Command-click (PC: Ctrl-click) on the RGB channel thumbnail to load the highlight areas as a selection. Then, create a new blank layer and fill the selection with black.

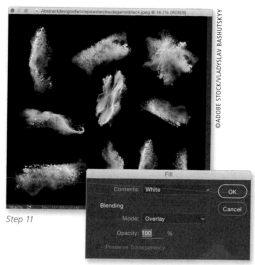

Step 11

Step 12

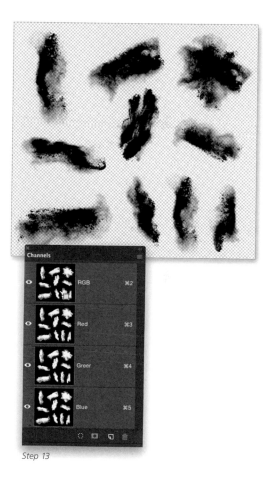

Step 13

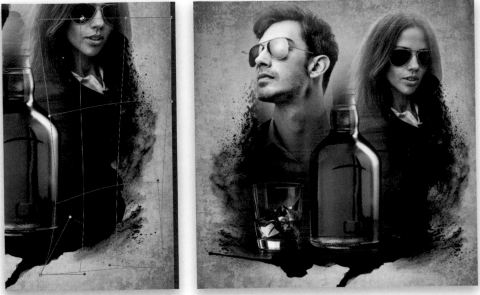

Step 14

Step 15

STEP 14: Use the Lasso tool (L) to make a loose selection of the top left particle shape, then get the Move tool and drag-and-drop it onto the main layout. Position the layer above the spatter layer in the Layers panel, and then position the particle element on the right side of the spatter in the composition and resize it using Free Transform. Now, because it is abstract, go under the Edit menu, under Transform, and choose Warp. Then, use the grid to change the shape of the particle element to better conform to the existing spatter. Press Return (PC: Enter) when done.

STEP 15: For the other side of the spatter, use a different particle element or just use the same one you already used, but this time, once you are in Free Transform, Right-click inside the bounding box and choose Flip Horizontal, then warp it again to change it a bit.

STEP 16: Now go to the layer with the original spatter and add a layer mask to it. Then, use a black radial gradient to fade around the particle edges to hide any superfluous areas.

STEP 17: Select the topmost layer in the Layers panel. Then, press-and-hold the Option (PC: Alt) key as you click in the top-right corner of the Layers panel and choose Merge Visible

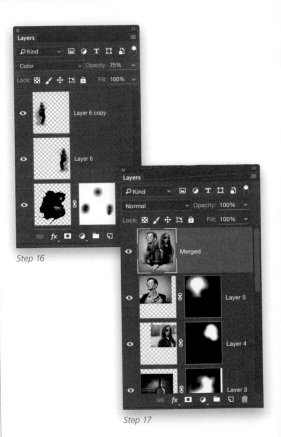

Step 16

Step 17

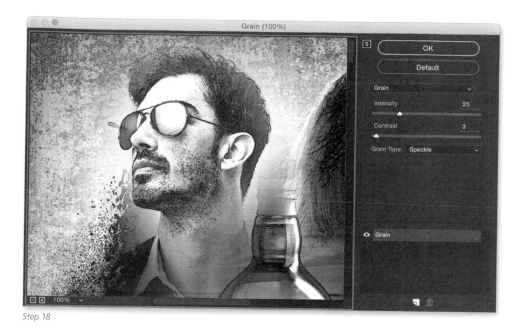

Step 18

Step 20

from the flyout menu. This will create a flat-tened version on a new layer at the top.

STEP 18: Press Command-Shift-U (PC: Ctrl-Shift-U) to remove the color from the layer. Then, go under the Filter menu and choose Filter Gallery, then under Texture, choose Grain. Set the Intensity to 25 and the Contrast to 3. Also, set the Grain Type to Speckle, and then click OK.

STEP 19: Press Command-U (PC: Ctrl-U) to open the Hue/Saturation dialog. Turn on the Colorize checkbox, then set the Hue to 30, the Saturation to 50, and the Lightness to –10. Click OK.

STEP 20: Set the layer's blend mode to Color. Add a layer mask and select the same Gra-dient tool we've been using, but go into the Options Bar and drop the tool's Opacity to 75%. Now add a few gradients to the center area to reveal the original, but with a hint of the textured layer showing through.

STEP 21: Finally, just drop in some text (using the Horizontal Type tool; I used the font Swiss721BT Black Extended) to finish the design, making sure the text layer is positioned above the other layers.

See the next page for the final image.

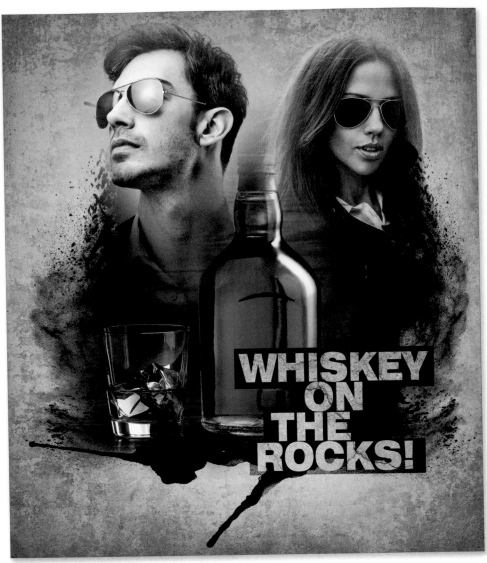

Final

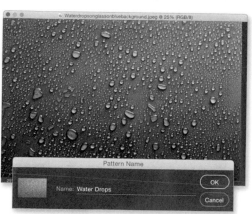

Here, we'll take a look at a creative way to use vector elements to frame your design. This is especially handy with commercial products, as it gives you a unique and customizable way to spice up an ad and be able to edit it easily throughout.

STEP ONE: Let's start by defining a texture we will add to the background. I like to define them as patterns because they will be there to use whenever I need them. Here, we have a water drop background that will work great.

STEP TWO: Remove the color from the image by pressing Command-Shift-U (PC: Ctrl-Shift-U), then go under the Edit menu and choose Define Pattern. Name it when prompted, and then click OK.

STEP THREE: Press Command-N (PC: Ctrl-N) and create a new document measuring 1000 pixels wide by 2000 pixels tall with the Background Contents set to black.

STEP FOUR: Go under the View menu and choose New Guide Layout. Just turn on the Margin checkbox and set all sides to 75 px. Click OK.

STEP FIVE: Grab the Rectangular Marquee tool (M) in the Toolbox, and click-and-drag out a selection in the rectangle defined by the guides. Click on the Create a New Layer icon at the bottom of the Layers panel, then press Shift-Delete (PC: Shift-Backspace) to open the Fill dialog, choose 50% Gray from the Contents pop-up menu, and click OK.

STEP SIX: Now, open the image of the subject of the ad. Here, we'll go with a fitness theme. Just use the Move tool (V) to drag-and-drop this image onto the main layout, and position the layer at the top of the layer stack in the Layers panel. Then, press Command-Option-G (PC: Ctrl-Alt-G) to clip the subject's layer into the gray layer, and use Free Transform (Command-T [PC: Ctrl-T]) to scale and position it to best fit in the frame.

STEP SEVEN: Click on the Background layer in the Layers panel, then add a new blank layer. Fill it with a base color, like 50% gray. Then, click on the Add a Layer Style icon at the bottom of the Layers panel and choose Pattern Overlay. Click on the Pattern thumbnail to open the Pattern Picker and choose the water drop pattern (it should be the last one). Adjust the scale, if necessary. Remember, you can also click directly on the image and move the texture around.

Set the Blend Mode to Overlay. Since the base color of the layer is gray, you will see no change, but if you change the layer color, then the water texture will blend accordingly. For instance, here I made the layer fill a little darker gray.

STEP EIGHT: Now select the Rectangle shape tool (U). Set the tool's mode to Shape in the Options Bar and set the color Fill to a yellow-gold. Draw a rectangle shape at the top of the canvas, going beyond the edge of the canvas on the top and both sides. This will automatically create a new shape layer. Now click on the Path Operations icon in the Options Bar and set it to Combine Shapes. Then, add a few more horizontal bars to the shape layer.

STEP NINE: Once you have all the bars in place, use the Path Selection tool (A) to select all of them by clicking-and-dragging out a rectangle around all of them. Then, go under the Edit menu, under Transform Path, and choose Skew. Move your cursor over the control point on either the left or right side, then press-and-hold the Option (PC: Alt) key and drag up or down to skew along this axis. Press Return (PC: Enter) when done.

Step 10

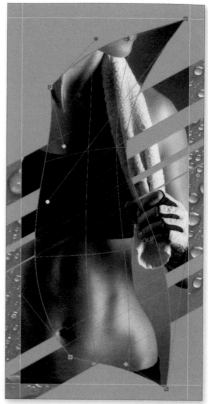

Step 11

STEP 10: With the paths still selected, grab the Rectangle shape tool again, press-and-hold the Option (PC: Alt) key, and starting in the center of the area you want to subtract, click-and-drag out a new rectangle that will be subtracted from the existing shapes, essentially hiding the shapes in the areas it overlaps. Use Free Transform to position the shape in the composition and keep it selected.

STEP 11: Go under the Edit menu, under Transform Path, and choose Warp. Yes, you can warp a vector path. Once the grid appears, manipulate the shape by clicking-and-dragging the individual points to warp it, which will result in a variation of the masking effect on the yellow bars. Press Return (PC: Enter) when done.

STEP 12: Click on the Add a Layer Style icon at the bottom of the Layers panel and choose Gradient Overlay from the pop-up

Step 12

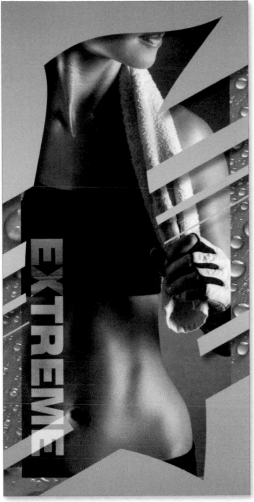

Final

menu. In the dialog, click on the gradient thumbnail and choose the Black, White gradient, and then set the Blend Mode to Soft Light. Also, set the Style to Reflected and turn on the Reverse checkbox, and use the Angle setting to set a different angle for the gradient.

Next, click on Drop Shadow on the left, then set the Opacity to around 42%, Distance to 26 px, Spread to 0, and Size to around 21 px. Then, just manually position the shadow by clicking directly on it in the image and dragging it where you want it. When you're done, click OK.

Finally, just use the Horizontal Type tool to drop in some text (I used the font Swiss721BT Black Extended), or drag-and-drop a logo onto the image, and you are all done.

CHAPTER 3

Graphic Effects

The great thing about Photoshop is its unending ability to incorporate graphic elements into your designs, especially vector graphics, not to mention the graphic effects you can apply to photo and texture elements. This chapter contains a few graphic tricks you can add to your design arsenal.

Graphic from a Photo, Blended with a Texture

I have seen this effect in numerous ads for movies and TV shows. It is a neat trick, even if you have a rather low-res photo, to be able to convert a photo to a black-and-white graphic, and then blend it with a texture.

STEP ONE: Start by opening the image of the main subject. (You can follow along by downloading these files from the book's downloads page, mentioned in the introduction.) Now, even though we are not extracting the subject for this effect, the simpler the background, the better. This one is a simple studio shot on a neutral background.

STEP TWO: Next, you need a texture for the background. (Again, you can use the one provided or use your own). This will also be the document we will use to build the design.

STEP THREE: With both files now open, go back to the main subject image and remove the color from the image by pressing Command-Shift-U (PC: Ctrl-Shift-U).

STEP FOUR: Press Command-L (PC: Ctrl-L) to open the Levels dialog. Select the white (highlights) eyedropper under the Options button, then go over to the image and click on the gray background area to the right of the subject's shoulder (as shown here). This will force most of the background to white.

STEP FIVE: Go back to the Levels dialog and grab the Input Levels shadows slider (the one on the left) below the histogram, and drag it to the right. Also move the midtones (middle) slider a little to the right, and then grab the highlights slider (on the right) and push it to the left a little. Do these adjustments until you have a pure black-and-white version of the subject. Click OK when you're done.

STEP SIX: Now use the Move tool (V) to drag-and-drop this image over onto the image of the background texture. Then, use Free Transform (Command-T [PC: Ctrl-T]) to scale and position the image in the composition, so it looks similar to the original.

STEP SEVEN: Once in place, change the subject's layer blend mode to Multiply. This will leave only the dark areas visible over the texture.

STEP EIGHT: Now, to give the subject layer a hint of color, press Command-U (PC: Ctrl-U) to open Hue/Saturation. Turn on the Colorize checkbox, set the Hue to around 34, and set the Saturation to around 32. This will put a warm cast on the subject layer, helping it blend with the background more.

STEP NINE: If you add a little more Levels adjustment after adding the color cast, you will get some interesting color effects. You can see where I moved the sliders here, but you can experiment here to get the look you want.

STEP 10: Next, click on the Add a Layer Style icon at the bottom of the Layers panel and choose Blending Options. Then, go down to the Blend If section, press-and-hold the Option (PC: Alt) key, and click on the white Underlying Layer slider knob to split it. Now, drag to the left to allow some of the background texture to peek through. Click OK.

STEP 11: As an option, you can take a texture, like this particle image, and just drag-and-drop it onto the main image. Then click-and-drag the layer in the Layers panel and position it between the Background layer and the subject layer in the layer stack. Also, use Free Transform to re-size and position the particle image within the background.

STEP 12: Now, just change the layer's blend mode to Color Burn and drop the layer's Opacity to 75%. If needed, you can always use the Horizontal Type tool (T) to drop in some text, and you are all done.

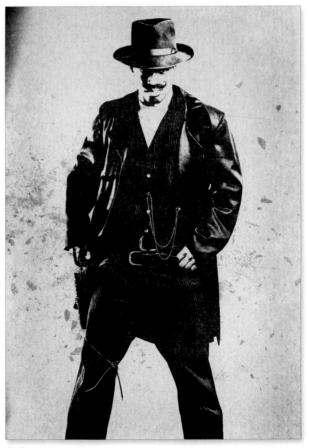

Final

Geometric Shape Elements

Oftentimes, a simple graphic element can make quite an impact if used the right way. Here, we will take a simple shape and make a custom brush which we will use to paint in a background element. I also have a couple bonus tips.

STEP ONE: Start by pressing Command-N (PC: Ctrl-N) to create a new document that is 2000 pixels wide by 1000 pixels tall. Then, click on the Create a New Layer icon at the bottom of the Layers panel to create a new blank layer. Click on the Foreground color swatch at the bottom of the Toolbox and, when the Color Picker opens, choose an orange color using the same RGB numbers I have here, then press Option-Delete (PC: Alt-Backspace) to fill your blank layer with this color.

STEP TWO: Next, create another new document, but this time, make it 1000 pixels by 1000 pixels at 300 pixels per inch.

STEP THREE: Then, go to the shape tools in the Toolbox and locate the Polygon tool (or click Shift-U until you have it). In the Options Bar, set the tool's mode to Shape, then set the Fill to none and the Stroke color to black. Also, near the right end, set the number of Sides to 3.

STEP FOUR: On your square document, start in the middle of the canvas and click-and-drag out a triangle shape. Do not take it beyond the image boundaries. If you want the stroke thicker or thinner, just go back to the Options Bar and enter a different amount for the Stroke size. *Note:* If you need to move the shape while you are creating it, just press-and-hold the Spacebar while you drag.

STEP FIVE: When you're done, go under the Edit menu and choose Define Brush Preset, then give the brush a name when prompted and click OK.

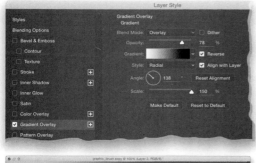

STEP SIX: Go back to the other document created in Step One and make sure the orange layer is selected in the Layers panel. Then, click on the Add a Layer Style icon, at the bottom of the Layers panel, and choose Gradient Overlay. Choose a simple Black, White gradient and change the Blend Mode to Overlay. Drop the Opacity to around 78%, set the Style to Radial, turn on the Reverse checkbox, and increase the Scale to 150%.

Once these settings are in place, you can click-and-drag on the image to position the center of the gradient over to the left side of the composition, like you see here. Click OK when you're done.

STEP SEVEN: Choose the Brush tool (B) and make sure the triangle brush is selected in the Brush Picker (it should be the last one). Then, click the little folder icon to the right of the Brush Picker to open the Brush panel. Click on Brush Tip Shape, set the Size to around 800 px, and increase the Spacing to around 150%. Next, click on Shape Dynamics on the left and set the Size Jitter and Angle Jitter to 100%. Then, click on Scattering, turn on the Both Axes checkbox, and set the Scatter amount to around 120%.

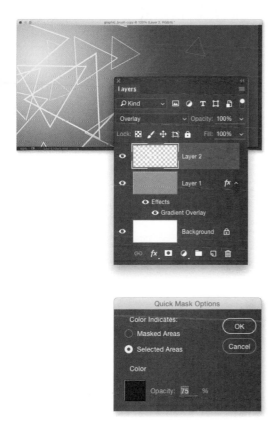

STEP EIGHT: Now we're going to use this brush. Click on the Create a New Layer icon to create a new blank layer and set the layer's blend mode to Overlay. Press D, then X, to set your Foreground color to white, and paint some random triangles around the background, starting in the light areas of the gradient, as shown here.

STEP NINE: This next step is just an option, but to add some blur effects to the graphics, start by double-clicking the Quick Mask icon (the second icon from the bottom of the Toolbox). In the Quick Mask Options dialog, make sure the Selected Areas radio button is turned on, and then click on the Color swatch and choose a bright medium blue color. Set the Opacity to 75%, and click OK.

STEP 10: Get the Gradient tool (G), choose the Foreground to Transparent gradient in the gradient thumbnail in the Options Bar, click on the Radial gradient icon to the right of the gradient thumbnail, and press Q to activate Quick Mask mode. Then, click-and-drag out a few gradients (as shown here; the blue is merely a color mask overlay). Press Q again to turn Quick Mask off and see your circular selections.

STEP 11: Next, go under the Filter menu, under Blur, and choose Gaussian Blur. Set the Radius to 10 pixels and click OK. Press Command-D (PC: Ctrl-D) to Deselect.

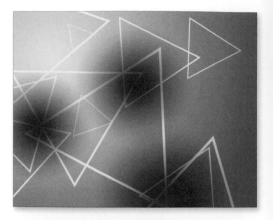

STEP 12: Now that we have the background done, here's an image of a skier that I want to mask on the background with a texture. So, go ahead and use the Move tool (V) to drag-and-drop this image into the main image. Use Free Transform (Command-T [PC: Ctrl-T]) to scale and position it.

©ADOBE STOCK/SAMOTT

STEP 13: Here's a texture that will be great to create a mask from. Remove the color by pressing Command-Shift-U (PC: Ctrl-Shift-U), then press Shift-Delete (PC: Shift-Backspace) to open the Fill dialog, and set the Contents to Black and the Mode to Overlay. Click OK.

©ADOBE STOCK/DULE964

STEP 14: Press Command-I (PC: Ctrl-I) to Invert the image. Then, in the Channels panel, press-and-hold the Command (PC: Ctrl) key and click on the RGB thumbnail to load the white area as a selection.

STEP 15: Now, with any selection tool chosen, click inside the active selection and drag it into the main image. Make sure the skier layer is selected in the Layers panel, and click on the Add Layer Mask icon at the bottom of the panel to mask the image inside the selected area.

STEP 16: Click on the chain link icon in between the image and mask thumbnails to unlink them. Then, click on the layer mask to select it, and use Free Transform to rotate and reposition the mask to better reveal the skier.

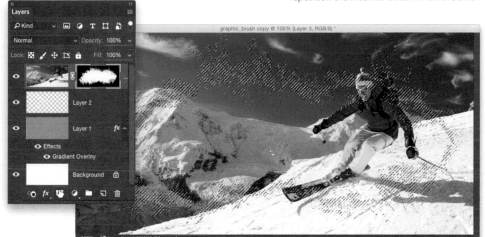

Step 15

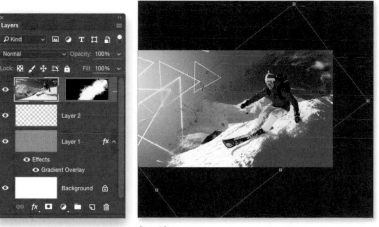

Step 16

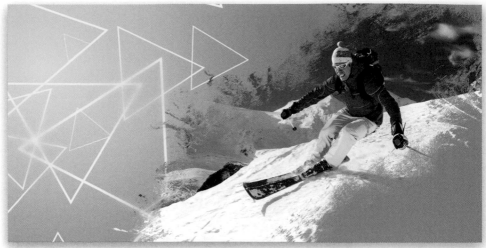

Final

Finally, if necessary, just use the Horizontal Type tool (T) to drop some text in, and you are all done.

©ADOBE STOCK/FET

HUD (heads-up display) graphics seem to be popping up everywhere. They can definitely add something to an image or design to really give it an instant cool look. Here we will look at defining HUD elements that you can use anytime you want.

STEP ONE: First you need to open up the HUD graphic element for this exercise, or if you have one that is similar to the one above, go ahead and use that.

STEP TWO: Now, remove the color using a Gradient Map because that gives it more contrast. So, press D to set your Foreground and Background colors to their defaults, then go under the Image menu, under Adjustments, and choose Gradient Map. Click OK when the dialog opens.

STEP THREE: Use Levels (press Command-L [PC: Ctrl-L]) to boost the contrast even more. The point here is to make the background mostly black and force the lighter areas to white. You can see where I have positioned the sliders here to keep some of the gray areas, as well. Click OK when you're done.

STEP FOUR: In the Channels panel, press-and-hold the Command (PC: Ctrl) key and click on the RGB channel to load the lighter areas as a selection. Press Command-J (PC: Ctrl-J) to copy this selected area to a new layer.

STEP FIVE: Turn off the Background layer (by clicking on the Eye icon to the left of its thumbnail), then go under the Edit menu, choose Define Pattern, and name the new pattern when prompted. When you have the graphic saved in Photoshop like this, you can use it any time you want without opening the image.

STEP SIX: Press Command-O (PC: Ctrl-O) and open an image that you want to apply the graphic to. Here, we have a cool fitness image. Go ahead and create a new document to build the design in (press Command-N [PC: Ctrl-N]) that is 2000 pixels wide by 1000 pixels tall. Then, use the Move tool (V) to drag-and-drop the image over onto the composition, and resize and position it using Free Transform (Command-T [PC: Ctrl-T]).

STEP SEVEN: Click on the Create a New Layer icon at the bottom of the Layers panel, and then press Shift-Delete (PC: Shift-Backspace) and fill it with a base 50% gray color (from the Contents pop-up menu). Then, click on the Add a Layer Style icon at the bottom of the panel and choose Pattern Overlay. Click on the Pattern thumbnail and locate the pattern you just defined (it should be the last one). Set the Blend Mode to Overlay and the Opacity to 75%. Also, increase or decrease the Scale until you like the size of the pattern.

STEP EIGHT: Click on Blending Options on the left and, in the Advanced Blending section, drop the Fill Opacity to 0%. Then, with the Layer Style dialog still open, just click on the image and drag it around to reposition the graphic in relation to the subject image. Click OK when you're done.

STEP NINE: Lastly, I just dropped in some white text (using the Horizontal Type tool [T] and the Eurostile Extended font), added a simple white Stroke layer style, and in the Blending Options, changed the Blend Mode to Overlay and dropped the Opacity a bit.

Remember, because the HUD elements are applied as layer styles, that means you can modify the settings at any time.

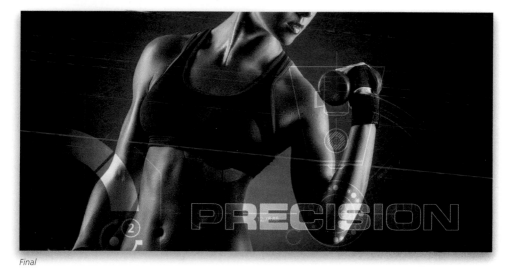

Final

Here is another example where less is more. Just by adding something as simple as a stroked box to a photo, and then masking certain elements, you can add an instant commercial look to a photo.

STEP ONE: Of course, start by pressing Command-O (PC: Ctrl-O) and opening the photo you want to use, or use this image from the book's downloads page (mentioned in the book's introduction).

STEP TWO: Select the Rectangle shape tool (U) in the Toolbox and then go up to the left end of the Options Bar and make sure the tool's mode is set to Shape. Set the Fill to none and the Stroke color to white. Leave the Size at 3 px for this image, but you may want to change it, depending on the size of your image.

STEP THREE: Click-and-drag out a rectangle over the image, as you see here. This will automatically create a new shape layer, and the path will appear as defined in the Paths panel.

STEP FOUR: Choose the Quick Selection tool (W) from the Toolbox, and then make sure the Background layer is selected in the Layers panel. Select the parts of the subject where the rectangle shape crosses over them, so here you only need to select part of her head (the top part of the rectangle) and her arms and side (the bottom part of the rectangle).

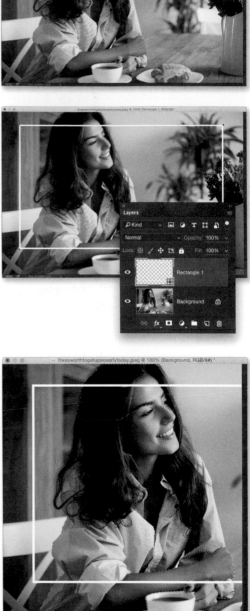

Step 5

STEP FIVE: Once your selection is in place, click back on the shape layer in the Layers panel. Then Option-click (PC: Alt-click) on the Add Layer Mask icon at the bottom of the panel to mask away the selected areas.

STEP SIX: Make a duplicate of the Background layer by selecting it and pressing Command-J (PC: Ctrl-J). Then, click back on the Background layer, click on the Create New Adjustment Layer icon at the bottom of the panel, and add a Hue/Saturation adjustment layer. Turn off the duplicate layer's Eye icon to hide it for now.

STEP SEVEN: In the Properties panel, turn on the Colorize checkbox, and set the Hue to 33, the Saturation to 26, and the Lightness to 10.

STEP EIGHT: In the Layers panel, reduce the Hue/Saturation layer's Opacity to around 55% to bring some of the original colors back into the image. Turn the duplicate layer's Eye icon back on and Option-click on the Add Layer Mask icon to add a Hide All layer mask.

Step 6

Step 8

STEP NINE: Now, set your Foreground color to white, and then with the layer mask active, just add a few gradients in the area of the subject to reveal the original color image. So, get the Gradient tool (G) and, up in the Options Bar, choose the Foreground to Transparent gradient in the Gradient Picker, then click on the Radial Gradient icon to the right of the gradient thumbnail, and click-and-drag out your gradients.

STEP 10: Finally, use the Horizontal Type tool (T) to drop some text inside the box area to finish it up (here, I used Futura Bold Condensed). You can see how adding just these couple simple elements can change the whole feel of the image.

Step 9

Final

This one was inspired by an ad I saw for a TV show. It was an interesting blend of photo and texture elements to get a cool design result. Along with some text, you can apply this design to just about anything.

STEP ONE: Start by pressing Command-O (PC: Ctrl-O) and opening the texture that will be used as the background. I like this texture because of the darker elements around the edges.

STEP TWO: Next, open a city skyline image. Here, we have a skyline image of Chicago, since the theme of our ad is a Chicago cop show.

STEP THREE: Press Command-N (PC: Ctrl-N) and create a new document (our working document) that is 2000 pixels by 1000 pixels. Then, use the Move tool (V) to drag-and-drop the texture image onto this document, and use Free Transform (Command-T [PC: Ctrl-T]) to scale and position it.

STEP FOUR: Next, go back to the image of the city and remove the color by pressing Command-Shift-U (PC: Ctrl-Shift-U), then go under the Filter menu and choose Filter Gallery. In the dialog, click on Texture, and then click on Grain. Choose Speckle for the Grain Type, set the Intensity to 7, the Contrast to 3, and click OK.

Note: You can have these filters appear in the Filter menu by going to Photoshop's Preferences (under the Photoshop [PC: Edit] menu), clicking on Plug-Ins, and turning on the Show All Filter Gallery Groups and Names checkbox.

STEP FIVE: Go under the Edit menu and choose Fade Grain. Set the blend Mode to Hard Light and click OK.

STEP SIX: Now, bring this processed city image into the main image with the texture layer and position it at the bottom of the document. In the Layers panel, set the layer's blend mode to Multiply and click on the Add Layer Mask icon at the bottom of the panel. Select the Gradient tool (G) and set your Foreground color to black. Then, in the Options Bar, choose the Foreground to Transparent gradient in the Gradient Picker, and click on the Linear Gradient icon. Click near the top center of the skyline image and drag downward to add a linear gradient fade at the top edge of the city layer.

STEP SEVEN: Click on the city skyline thumbnail in the Layers panel, and press Command-U (PC: Ctrl-U) to open the Hue/Saturation dialog. Turn on the Colorize checkbox, then set the Hue to around 209, the Saturation to 39, and the Lightness to 25.

STEP EIGHT: Select the Horizontal Type tool (T) in the Toolbox, and click on the canvas to add a new text layer. Here, I have set the title in Eurostile Extended 2 and Eurostile Bold Extended 2. For the color, I merely clicked on the color swatch in the Options Bar, and then sampled the darker blue area of the city graphic using the Eyedropper tool. I tweaked the tracking and leading using the Character panel. I also changed the layer's blend mode to Multiply to darken the text a little more.

STEP NINE: Next, click on the Add a Layer Style icon at the bottom of the Layers panel, and choose Pattern Overlay. In the Pattern Picker, I chose the cracked texture used in the Stone Age Text exercise in Chapter 1. Set the Blend Mode to Hard Light, then drop the Opacity to 40%, and increase the Scale to around 125%. Don't click OK yet.

STEP 10: Click on Blending Options at the top left, and go to the Blend If section. Press-and-hold the Option (PC: Alt) key as you click on the white Underlying Layer slider knob to split it, then drag the knob to the left a little. This will allow the background texture to show through a bit. Click OK.

STEP 11: Now, one final effect: click on the Create a New Layer icon at the bottom of the Layers panel to add a new blank layer and change its blend mode to Color Burn. Then, select the Gradient tool and make sure the Foreground to Transparent gradient is still selected, and click on the Radial Gradient icon. Option-click (PC: Alt-click) on the background texture to make that color your Foreground color, and then add a few gradients around the top edges to enhance the texture color.

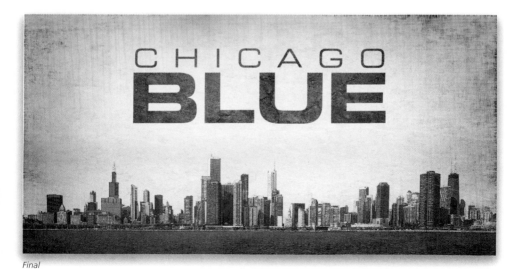

Final

Chapter Four

Photo Effects

Little design is done these days without a photo being used at some point. Photos can be part of a design or can be the design themselves. In this chapter, we will explore a few ways to take your photos to the next level and turn even the most seemingly mundane shots into amazing design elements!

Sketch Fade Effect

This is a really cool effect I have used for years. It's really quite simple to achieve and can be used on almost any photo. I will often use this effect to make an otherwise dull photo a bit more interesting, or it can be used in a commercial sense as a background image for a product.

STEP ONE: Begin by pressing Command-O (PC: Ctrl-O) and opening the photo you want to apply the effect to (or just download the photo I am using here from the book's downloads page, mentioned in the book's introduction).

STEP TWO: Now, press Command-N (PC: Ctrl-N) and create a new document that is 2000 pixels wide by 1300 pixels tall to build the final design in.

STEP THREE: Once the document is created, let's add a light-colored texture to it. This will be the base texture the design will be built on. You can also use a simple solid color if you like, as well. So, open the texture image (you can download this one from the book's downloads page, too), use the Move tool (V) to drag-and-drop it into your new document, and then press Command-T (Ctrl-T) to activate Free Transform and scale it to fit. Press Return (PC: Enter) when done.

STEP FOUR: Now, let's drag-and-drop the photo from Step One into this document. Activate Free Transform, again, and scale it to fit in the canvas area. Press Command-J (PC: Ctrl-J) to make a duplicate of the subject layer, then click on the duplicate's Eye icon to turn it off for now. Reselect the original subject layer.

STEP FIVE: Go under the Filter menu, under Stylize, and choose Find Edges. This will create an instant sketch look on the photo. You will see some color in the lines, so press Command-Shift-U (PC: Ctrl-Shift-U) to make it black and white. Now, open Levels by pressing Command-L (Ctrl-L) and adjust the highlights (white) and midtones (light gray) sliders (beneath the histogram) to force the background to white and reduce other light gray areas. Click OK.

STEP SIX: In some cases, the lines may be thicker than you want them to be. To fix that, go under the Filter menu again, under Other, and choose Maximum. Set the Radius to 0.5. Other images may require a higher setting, so you will have to experiment a little. Choose Roundness from the Preserve pop-up menu and click OK.

STEP SEVEN: Change the layer's blend mode to Multiply to hide the white area, and then drop its opacity to around 75%. Next, press Command-U (Ctrl-U) to open the Hue/Saturation dialog. Turn on the Colorize checkbox, and then set the Hue slider to whatever color you'd like the lines to be. Here, I chose a light blue color by setting it to 191. Click OK.

STEP EIGHT: Turn the duplicate layer at the top of the layer stack back on, and then select it. Go under the Filter menu, and choose Filter Gallery, and then under Texture, click on Grain. Again, the settings here will vary with different images, but for this one, I set the Grain Type to Speckle, the Intensity to 10, and the Contrast to 15. Click OK. (*Note:* To have all the Filter Gallery filters appear in the Filter menu, open Photoshop's Preferences and, on the Plug-Ins tab, turn on the Show All Filter Gallery Groups and Names checkbox).

STEP NINE: Set this layer's blend mode to Multiply, as well, then press-and-hold the Option (PC: Alt) key and click on the Add Layer Mask icon at the bottom of the Layers panel. This will add a black layer mask, which hides the entire layer.

STEP 10: Select the Brush tool (B) from the Toolbox, choose a simple, round, soft-edged brush from the Brush Picker in the Options Bar, and then open the Brush panel (Window>Brush). Now, if you are using a pressure-sensitive tablet, click on Transfer on the left and set the Opacity Jitter and Flow Jitter Control pop-up menus to Pen Pressure. This allows you to reveal the image based on how hard you press. If you do not have a pressure-sensitive tablet, then just set the brush Opacity to 50% in the Options Bar. Each stroke will build upon the next as you paint.

STEP 11: Once the brush is set, press D to set your Foreground color to white, and then start painting on the layer mask in the area of the subjects you want to reveal. How much you reveal is up to you, but like I always say, don't overdo it.

Once it looks good to you, you can drop in some text (I used the font Futura Medium with a Stroke layer style) or a logo for a finished commercial look.

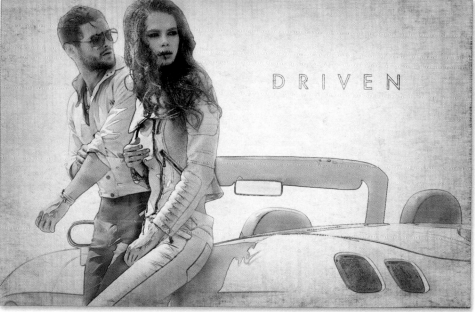

Final

Here's a cool light and color effect technique that adds a fantasy-like lighting look to a photo by taking a photo of a subject shot in a studio setting and blending them into an outdoor scene.

STEP ONE: Begin by pressing Command-O (PC: Ctrl-O) and opening the image of the subject. As always, you can download the image we're using here from the book's downloads page, mentioned in the book's introduction. (*Note:* I would recommend following along with the download files, so you get a better understanding of the technique. Then, experiment with other images afterwards.) We'll need to extract the subject here, so get the Quick Selection tool (W) and paint over her to make an initial selection.

STEP TWO: Click on the Refine Edge button up in the Options Bar and, in the dialog, select the Refine Radius tool, and then make your brush Size a little larger than one of the subject's eyes. Now, brush in the areas of her hair to include the rest of it. Do this to all the hair edges and any other edges that need to be selected. Also, boost the Contrast to around 15% to tighten up the selection around the softer edges. When you're done, set the Output To pop-up menu to New Layer and click OK.

STEP THREE: Next, open the background image. We're using a rather ominous outdoor scene, here, which will make a cool background for the composite. The challenge is to make the studio-shot subject blend with this outdoor scene, but let's modify the scene a bit first. Press Command-R (Ctrl-R) to reveal the Rulers, then click on the vertical ruler on the left and drag a vertical guide to the center of the image. It should snap in place when you get close (if you have the Snap To Guides setting turned on in the View menu).

©ADOBE STOCK/GROMOVATAYA

©ADOBE STOCK/GUDELLAPHOTO

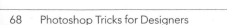

STEP FOUR: Make a duplicate of the Background layer by pressing Command-J (PC: Ctrl-J), then go under Edit menu, under Transform, and choose Flip Horizontal. Get the Rectangular Marquee tool (M) from the Toolbox and draw a selection over the left half of the image, then click on the Add Layer Mask icon at the bottom of the Layers panel to mask the unselected area. This creates an instant symmetrical image. You can get a different view by selecting the layer mask and pressing Command-I (PC: Ctrl-I) to Invert the values and thus revealing the other half of the image on each side (as I did here). It's magic.

STEP FIVE: Once you decide which one you like, press-and-hold the Option (PC: Alt) key, and from the Layers panel's flyout menu, choose Merge Visible to create a merged copy at the top of the layer stack.

STEP SIX: Now, using the Move tool (V) click-and-drag this new scene into the subject image, placing its layer below the extracted subject layer in the layer stack. Then, press Command-T (PC: Ctrl-T) to activate Free Transform and scale it to fit in the scene however you want it. When you're done, click on this layer's Eye icon to turn it off for the moment, and then select the extracted subject layer.

STEP SEVEN: With only the subject layer visible now, open the Channels panel (Window>Channels), press-and-hold the Command (PC: Ctrl) key, and click on the main RGB channel thumbnail to select the bright areas. Press Command-Shift-I (PC: Ctrl-Shift-I) to Inverse the selection, then press Command-J (PC: Ctrl-J) to copy the selected area to a new layer.

STEP EIGHT: Now, press Command-U (PC: Ctrl-U) to open the Hue/Saturation dialog. Turn on the Colorize checkbox, and then set the Hue to 220 and the Saturation to 35. Click OK.

STEP NINE: Set the layer's blend mode to Multiply, then press Command-J (PC: Ctrl-J) to duplicate it. Drop the Opacity of this duplicate layer to 75%, and then turn the outdoor scene layer back on. You can also turn off the original Background layer (if it's still on).

STEP 10: Select the original extracted subject layer, then press-and-hold the Command (PC: Ctrl) key and click on its thumbnail. Then, go under the Select menu, under Modify, and choose Contract. Set the amount to 10 pixels and click OK.

STEP 11: Press Command-Shift-I (PC: Ctrl-Shift-I) to Inverse the selection, and then press Command-J (PC: Ctrl-J) to copy the edge selection to a new layer. Go under the Filter menu, under Blur, and choose Gaussian Blur. Set the Radius to 10 pixels and click OK. Change the layer's blend mode to Color Dodge, then press Command-J (PC: Ctrl-J) to create a duplicate to intensify the edge effect.

STEP 12: Command-click (PC: Ctrl-click) on the first edge layer to select both edge layers, and then press Command-G (PC: Ctrl-G) to put them in a group. Drop the group's layer Opacity to 65%, and then move the group to the top of the layer stack.

STEP 13: Command-click (PC: Ctrl-click) on the original extracted subject layer's thumbnail to make another selection. Then, click on the Create a New Layer icon at the bottom of the Layers panel to create a new blank layer, and move it below the subject layer. Press Shift-Delete (PC: Shift-Backspace) to open the Fill dialog and change the Contents to White.

STEP 14: Press Command-D (PC: Ctrl-D) to Deselect, then go under Filter menu, under Blur, and choose Gaussian Blur, again. Set the Radius to 25 and click OK. Now, set the layer's Opacity to around 80%.

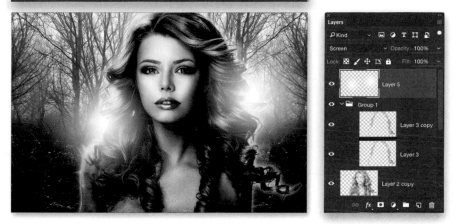

STEP 15: Create another blank layer, move it to the top of the layer stack, and set its blend mode to Screen. Press D, then X, to set your Foreground color to white. Select the Gradient tool (G) and, in the Options Bar, click on the gradient thumbnail and choose the Foreground to Transparent gradient. Also, click on the Radial Gradient icon (second icon to the right of the gradient thumbnail). Then, click-and-drag out a couple gradients on each side of the subject to create a light flare effect.

STEP 16: Now, create one more blank layer, then click on the Linear Gradient icon in the Options Bar, set the gradient Opacity to 75%, and then press X to set your Foreground color to black. Click-and-drag a gradient from just below the bottom edge up a little ways to create a subtle fade.

STEP 17: Finally, select the background scene layer, then go under the Filter menu, under Blur, and choose Gaussian Blur, again. This time, set the Radius to 5 and click OK. This will create a depth-of-field effect.

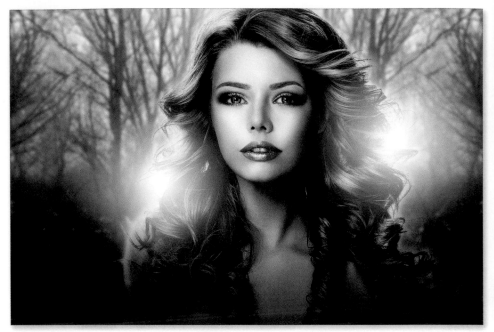

Final

©ADOBE STOCK/PAFFY

There are, of course, many ways to achieve a double exposure effect, as it has become quite a popular look these days. Here is a simple way to achieve that effect with some layer tricks. This is one of those techniques that once you have it figured out, you'll try it on almost everything.

STEP ONE: Start by pressing Command-O (PC: Ctrl-O) and opening the image of the subject you want to use as the base shape for the effect. Here, we have a profile shot of a model on a simple background for easy extracting.

STEP TWO: Get the Quick Selection tool (W) and paint over the subject to select her. Then, click on the Refine Edge button, up in the Options Bar, and use the Refine Radius tool to adjust the selection around her hair and any other soft areas. Choose New Layer from the Output To pop-up menu near the bottom of the dialog, then click OK.

STEP THREE: Now, press Command-N (PC: Ctrl-N) and create a new document measuring 1400 pixels wide by 2000 pixels tall, with the Background Contents set to White. Use the Move tool (V) to drag-and-drop the extracted subject over onto this new document, and then press Command-T (PC: Ctrl-T) to activate Free Transform and scale and position it like I have it here. Press Return (PC: Enter) when done. Now, desaturate the subject by pressing Command-Shift-U (PC: Ctrl-Shift-U).

STEP FOUR: Next, open the city street image. This is a cool one to blend with the subject for this double exposure effect because it has interesting negative space in the sky area, which will have a cool result in the final image. First, though, we need to change some things: Desaturate the image (like we just did with the subject), and then press Command-L (PC: Ctrl-L) to open Levels. Click on the highlights (white) eyedropper, beneath the Options button, and then click in the sky area to force it to white. Now, push the shadows (black) slider, beneath the histogram, to around 25 to boost the overall contrast. Click OK when done.

STEP FIVE: Press Command-A (PC: Ctrl-A) to select the entire image, then go under the Edit menu, under Transform, and choose Flip Horizontal (I discovered that the blend worked better when I flipped it, so don't be afraid to try that to get a different result you might like better). Now, drag-and-drop this image onto the main layout, and use Free Transform to scale and position it toward the top of the subject.

STEP SIX: With the city layer still selected, press Command-Option-G (PC: Ctrl-Alt-G) to clip it inside the subject layer below, and then click on the Add Layer Mask icon at the bottom of the Layers panel. Get the Gradient tool (G), click on the gradient thumbnail in the Options Bar, choose the Foreground to Transparent gradient, and then click on the Radial Gradient icon (the second icon to the right of the gradient thumbnail). With your Foreground color set to black, add a few gradients in the areas where you want to see the face of the subject. Don't overdo it, though.

STEP SEVEN: Now, we're going to blend one more image. I want to add this dead trees image to the bottom of the subject at the neck area. Again, start by removing the color info by pressing Command-Shift-U (PC: Ctrl-Shift-U), then use Levels to force the sky to white (I pushed the shadows slider to around 60 this time).

STEP EIGHT: Open the Channels panel (Window>Channels), then press-and-hold the Command (PC: Ctrl) key and click on the RGB channel thumbnail to load the luminosity as a selection. Press Command-Shift-I (PC: Ctrl-Shift-I) to Inverse the selection to the trees. Finally, press Command-J (PC: Ctrl-J) to copy the selection to a new layer.

STEP NINE: Now, drag-and-drop this trees image into the main layout. Activate Free Transform, then Right-click and choose Rotate 180° to flip the layer upside down. Also, scale and position it down by the neck area of the subject. Right-click once again, and choose Warp from the pop-up menu. Use the control handles around the mesh to reshape the trees image to the contours of the neck shape. Press Return (PC: Enter) when done. Now, just add a layer mask to this layer, then get the Gradient tool again, click on the Linear Gradient icon (the first icon to the right of the gradient thumbnail) in the Options Bar, and use the Foreground to Transparent gradient to fade the top edge of the trees layer to blend with the subject. I also added a layer mask to the subject layer and, with the Brush tool (B), used a low-opacity black brush to fade the bottom edge of her neck.

STEP 10: Now we need to add a texture to the background. Here's one that has good texture to it, but I don't really care for the color. No problem. Just desaturate this texture (just like before), then bring it over onto the main image, placing it just above the Background layer in the layer stack, and drop the layer's Opacity to 50%.

STEP 11: Click on the Add a Layer Style icon at the bottom of the Layers panel and choose Gradient Overlay. Click on the Gradient thumbnail and choose the Foreground to Background gradient, then set the Style to Radial. Set the Blend Mode to Linear Burn, the Opacity to 85%, and the Scale to 150%. Finally, turn on the Reverse checkbox and adjust the Angle slightly to give the background a subtle vignette effect. Click OK when done.

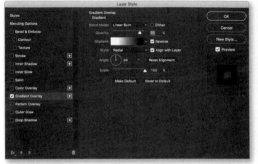

STEP 12: Now, select the main subject layer in the Layers panel and set the layer blend mode to Multiply. This will drop the white from the blended image and let the texture show through. Also, select the trees layer and drop the layer Opacity to 60%.

STEP 13: With the trees layer still selected in the Layers panel, click on the Create New Adjustment Layer icon at the bottom of the panel and choose Gradient Map. Click on the gradient in the Properties panel to open the Gradient Editor. Then, click on the gear icon to the right of Presets and choose Photographic Toning from the flyout menu. Click OK in the dialog that appears, then choose the Cobalt-Iron 2 preset at the bottom of the presets, and click OK.

At this point you are pretty much done short of any adjustments you want to make. For instance, I did a further Levels adjustment to the subject layer to help better match the contrast of the city image. As a final option, you can drop in some text (I used the font Futura Book), and you're all set.

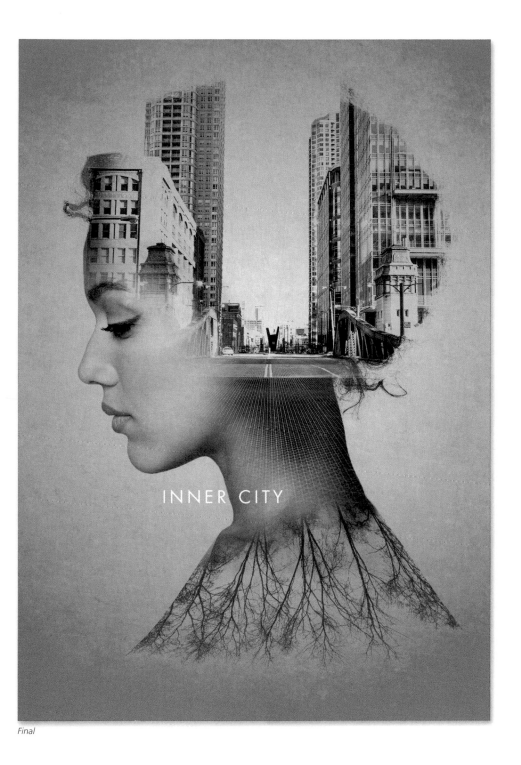

INNER CITY

Final

This is an effect I saw over on Pinterest (lots of cool ideas floating around there). I loved the result and the elegance of the technique—so simple, yet so effective.

STEP ONE: Start by pressing Command-N (PC: Ctrl-N) and creating a new document that's 500 pixels by 500 pixels at 100 ppi, with the Background Contents set to White.

STEP TWO: Choose the Ellipse shape tool (press Shift-U until you have it) from the Toolbox and then, up in the Options Bar, set the Tool Mode to Shape, the Fill to black, and the Stroke to none. Press-and-hold the Shift key, click on the upper-left corner, and drag to the lower-right corner to create a circle in the square (press-and-hold the Spacebar as you drag to reposition the circle). You will want the edges of the circle to touch the edges of the canvas, if not extend beyond just a tiny bit. Once you have the shape drawn, click on the Eye icon to the left of the Background layer to turn it off, so you can see transparency.

STEP THREE: Go under the Edit menu and choose Define Pattern. Give the pattern a name and click OK.

STEP FOUR: Create another new document that's 1500 pixels wide by 2000 pixels tall, with a white background. Click on the Create a New Layer icon at the bottom of the Layers panel, and then press Shift-Delete (PC: Shift-Backspace) to open the Fill dialog. Choose 50% Gray from the Contents pop-up menu and click OK.

STEP FIVE: Now, click on the Add a Layer Style icon at the bottom of the Layers panel and choose Pattern Overlay. Click on the Pattern thumbnail and locate the circle pattern we just created (it should be the last one), then use the Scale setting to change the size of the pattern. Here, I set it to 35%. You can also move the pattern around manually by clicking directly on it in the image window and dragging it around to change its position. Click OK when done.

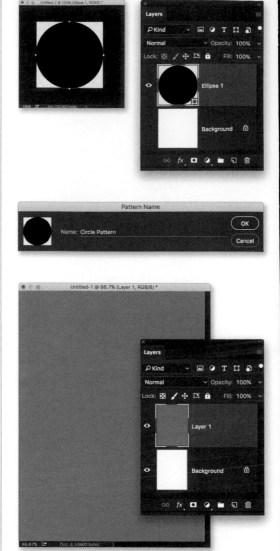

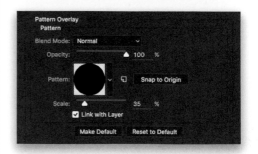

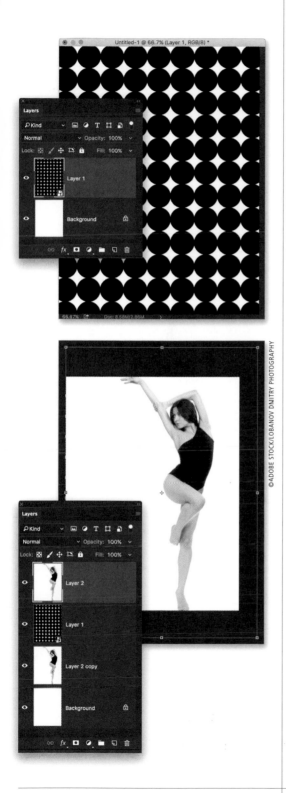

©ADOBE STOCK/LOBANOV DMITRY PHOTOGRAPHY

STEP SIX: We now need to clip an image layer with the circle layer, but it won't work right now because it would clip based on the gray fill and not the circles. So, first we need to get rid of the gray by simply dropping the layer Fill setting to 0%, near the top right of the Layers panel. Then, Right-click on the circle layer and choose Convert to Smart Object. This will maintain the transparency without having to rasterize the layer. (*Note:* The Fill setting will go back to 100% after you choose this.)

STEP SEVEN: Next, press Command-O (PC: Ctrl-O) and open the subject image you want to use. Here, we have a dancer on a white background (you can download this from the book's companion webpage, mentioned in the book's introduction). Drag-and-drop the image into the working layout, and then press Command-T (PC: Ctrl-T) to activate Free Transform and position it in the composition. Press Return (PC: Enter) once it's positioned, then press Command-J (Ctrl-J) to make a duplicate of this layer, and place one layer above and one below the pattern layer (as shown here).

STEP EIGHT: Select the subject layer at the top of the layer stack, and then press Command-Option-G (PC: Ctrl-Option-G) to clip it to the pattern layer below.

STEP NINE: Now, select the other subject layer below the pattern layer and activate Free Transform, again. Move this layer to the left a little bit and then scale it up (press-and-hold the Shift key to keep it proportional), and you will see the effect take shape. Notice how I positioned this subject layer in relation to the one above the pattern layer. If using other images, the arrangement may take some trial and error. Press Return (PC: Enter), and then drop the layer's Opacity to 75%.

STEP 10: Select the subject layer at the top of the layer stack again, and then click on the Create New Adjustment Layer icon at the bottom of the Layers panel and choose Gradient Map. Click on the gradient in the Properties panel to open the Gradient Editor. Then, click on the gear icon to the right of Presets and choose Photographic Toning (the same presets we used in the last technique) from the flyout menu. Click OK in the dialog that appears, then choose the Sepia-Cyan preset and click OK.

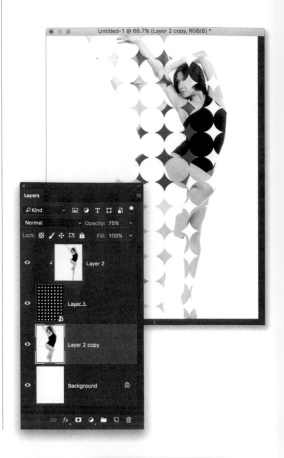

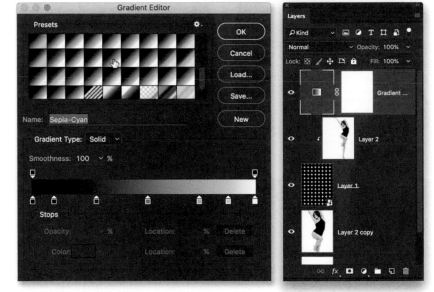

Finally, I added some text using the Eurostile ExtendedTwo font that I filled with white and blended by choosing the Difference layer blend mode, which makes the text dark on light backgrounds and light on dark backgrounds.

Final

CHAPTER 5

Texture Effects

I am a huge fan of textures. I have as many texture images in my library as I do stock images. Textures are all around you everyday and now, with advanced smartphones, you can capture them on your phone and implement them right into your workflow. In this chapter, we'll look at a few cool ways to use textures in Photoshop.

Here, we have a couple cool techniques you can use separately or combined, as I have. We will look at defining a seamless texture, then creating a custom-lit background, and then we will blend a logo to the texture.

STEP ONE: Let's start with the texture itself. I did a simple search for a seamless diamond plate texture over at Adobe Stock. It is easier to find a ready-made seamless texture than to make one, as there are quite a few on the site. *Note:* You can check that it is seamless by opening the texture, then going under the Filter menu, under Other, and choosing Offset. Set the offset to any numbers within the image dimensions and turn on Wraparound. If the texture is truly seamless, you should see no edges in the tiling. Click Cancel when done.

STEP TWO: With the seamless verified, go under the Edit menu and choose Define Pattern. Then, name the pattern and click OK.

STEP THREE: Now, press Command-N (PC: Ctrl-N) and create a new document that is 2000 pixels wide by 1200 pixels tall. Set the Background Contents to White.

STEP FOUR: Click on the Create a New Layer icon at the bottom of the Layers panel to create a blank layer, and then press Shift-Delete (PC: Shift-Backspace) to fill it with any color. Here, I set the Contents to 50% Gray. This is just a base fill on the layer for the layer style we are going to apply next.

STEP FIVE: Click on the Add a Layer Style icon at the bottom of the Layers panel and choose Pattern Overlay from the pop-up menu. Click on the Pattern thumbnail to open the Pattern Picker, and choose the diamond plate pattern defined in Step Two (it should be the last one). Once the pattern is selected, you can adjust the Scale. It will tile the pattern automatically, hence the reason for a seamless pattern. Here, I have it set to 45%. You can also click directly on the image and move the pattern around manually. Do *not* click OK yet.

STEP SIX: Next, click on Gradient Overlay on the left. Make sure you have the simple Black, White gradient chosen, then set the Blend Mode to Multiply. Set the Opacity to around 90%, the Style to Radial, and turn on the Reverse checkbox so the light area is the center of the gradient. Also, increase the Scale to around 130%.

You can also click on the image and drag the gradient around, thus changing the lighting on the texture. Here, I dragged the light area to the center of my image. I use this Gradient Overlay method for lighting effects all the time. In fact, I've used it a few other times in this very book. Click OK when you are done, but remember it's a layer style, so you can change the settings whenever you want.

STEP SEVEN: Now that we have set the scene, we just need to add a subject or graphic. Here, we have a simple graphic element. Get the Move tool (V) and drag-and-drop it onto the texture. We'll blend it using an old, but handy, feature.

STEP EIGHT: With the graphic in place and its layer positioned above the texture layer in the Layers panel, click on the Add a Layer Style icon again, and choose Blending Options.

STEP NINE: Go to the General Blending section and change the Blend Mode to Hard Light. Then, go down to the Blend If section at the bottom. Press-and-hold the Option (PC: Alt) key and click on each of the Underlying Layer slider knobs to split them as you drag them toward the center to allow the texture below to peek through the graphic. In this case, I only needed to split the shadows slider knob. This gives the graphic a worn-out, aged look. Where you position the slider knobs depends on how much of the effect you want. Click OK when done. I also added a little text, using the Horizontal Type tool (T) and the font Swiss721BT Black Extended, and blended it the exact same way as the graphic.

Now you can define a texture, scale it, light it, and then blend a graphic with it realistically. And, all of this is non-destructive to the layers themselves.

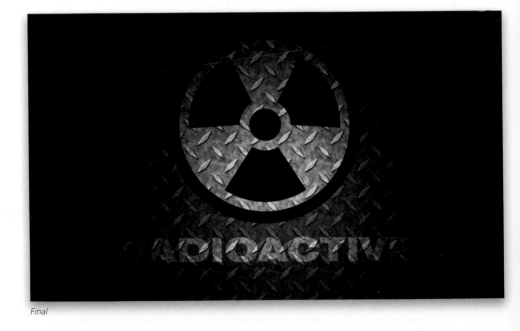

Final

Here is an example of using a texture again as a base element for a composite design. You can combine elements from images with different lighting, and essentially use a texture to hide any blending problems.

STEP ONE: First, press Command-N (PC: Ctrl-N) and create a new document to build the finished the design in. Here, we're going with a sort of square format with the Width at 1000 pixels and the Height at 1200 pixels. Set the Background Contents to White.

STEP TWO: Now, press Command-O (PC: Ctrl-O) and open the texture image. Here, we have a good one that I found over at Adobe Stock, and that you can download from the book's downloads page (mentioned in the book's introduction). It has good texture and color all around.

STEP THREE: First, make this texture vertical by going under the Image menu, under Image Rotation, and choosing 90° Clockwise, since our layout is slightly more vertical. Then use the Move tool (V) to drag-and-drop this image onto your new document.

STEP FOUR: Once it's there, press Command-T (PC: Ctrl-T) to activate Free Transform, then press-and-hold the Option (PC: Alt) key while you click-and-drag a corner handle to disproportionately resize the texture from both sides to fit in the visible canvas area. Press Return (PC: Enter) when done.

STEP FIVE: Make a duplicate of this texture layer by pressing Command-J (PC: Ctrl-J), then reselect the original layer below the duplicate. Go under the Filter menu, under Blur, and choose Average. This will fill the layer with the overall dominant color of the texture.

STEP SIX: Reselect the duplicate layer, change its blend mode to Multiply, and drop the layer's Opacity to around 90%. We will come back to this layer in moment.

STEP SEVEN: Now, open the subject image, which in this case is a football player on a white background for easier extraction. Just use the Quick Selection tool (W) to make a selection of the background. If you select any of the subject, press-and-hold the Option (PC: Alt) key and paint back over that area. Once your selection is done, press Command-Shift-I (PC: Ctrl-Shift-I) to flip the selection to the subject.

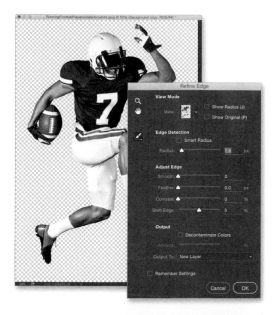

STEP EIGHT: Click on the Refine Edge button in the Options Bar. There aren't really any soft edges here to necessitate the Refine Radius tool, so just nudge the Edge Detection Radius slider to around 1.5 px, and then set the Output To pop-up menu to New Layer. Click OK. Once it is extracted, go ahead and run a 2-pixel defringe on the layer by going under the Layer menu, under Matting, and choosing Defringe.

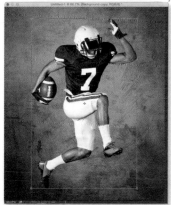

STEP NINE: Go ahead and drag-and-drop this subject over the texture background in the main document. Use Free Transform to scale and center him in the composition, if needed.

STEP 10: Now, open the image of the stadium. Yes, I realize that this is a photo of a soccer field, but we won't see the field part in the final anyway. I just like the way the stands and lights look in this one.

STEP 11: Press D to set your Foreground and Background colors to their defaults, then go under the Image menu, under Adjustments, and choose Gradient Map. This will remove the color and leave more contrast than just desaturating.

STEP 12: Drag-and-drop this stadium image over onto the main image and place it above the texture layer and below the subject layer in the Layers panel. Then, use Free Transform to scale and rotate the image, as you see here. Press Return (PC: Enter) when done.

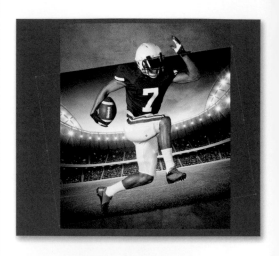

STEP 13: Click on the Add Layer Mask icon at the bottom of the Layers panel to add a mask to this layer, then select the Gradient tool (G). With the default colors still set, click on the gradient thumbnail in the Options Bar and choose the Foreground to Transparent gradient in the Gradient Picker, and then click on the Linear Gradient icon to the right of the thumbnail. Click-and-drag in from all four sides to fade the image into the background texture. Then, change the layer's blend mode to Multiply.

To add some color to this layer, click on the stadium image's thumbnail in the Layer's panel and press Command-U (PC: Ctrl-U) to open the Hue/Saturation dialog. Turn on the Colorize checkbox, and set the Hue to 35 and the Saturation to 25, then click OK.

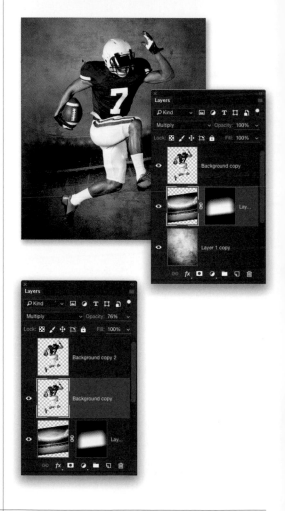

STEP 14: Select the subject layer in the Layers panel, and make a duplicate by pressing Command-J (PC: Ctrl-J). Click on the Eye icon to the left of the duplicate layer's thumbnail to turn the layer off, and reselect the layer below. Do the exact same color effect we did in the last step to this layer. Also, change the blend mode to Multiply and then drop the layer's Opacity to around 75%.

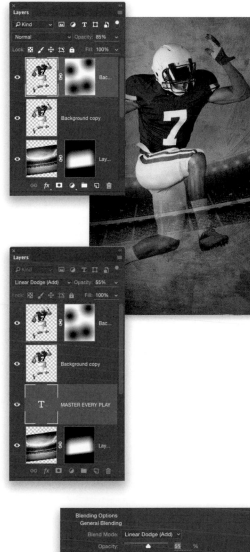

STEP 15: Turn the duplicate layer back on, and set its Opacity to 85%. Then, add a layer mask, and with the Gradient tool still active, click on the Radial Gradient icon. Use a radial foreground-to-transparent gradient to fade this layer around the arms and legs to reveal the monochromatic image below (as shown here).

STEP 16: Now, the last thing is to drop in some text using the Horizontal Type tool (T). Here, I added the words "MASTER EVERY PLAY" using the font Impact in all caps and filled with a color sampled from the background. Drag the text layer below the subject layer, but above the stadium layer, in the layer stack and set the layer's blend mode to Linear Dodge (Add) and Opacity to 55%.

STEP 17: Finally, double-click on this text layer to open the Blending Options and, in the Blend If section at the bottom, Option-click (PC: Alt-click) on the shadows (dark gray) Underlying Layer slider knob to split it, and spread both halves apart to allow more of the darker areas of the texture to show through. Click OK when you're done.

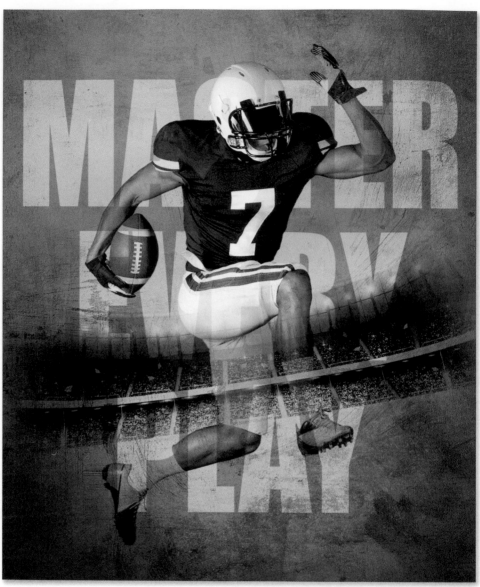

Final

©ADOBE STOCK/ANDREY KUZMIN

Here we will look at another way of blending textures, with a photo of a model in the mix. Being able to utilize layer styles in various ways affords you the flexibility to modify the effect whenever you want.

STEP ONE: Open this first texture (you can find it on the book's downloads page, mentioned in the book's introduction). It is sized to 1700 pixels by 1100 pixels.

©ADOBE STOCK/EDWARDDERULE

STEP TWO: Next, open the subject image. I chose this one because the lighting and color are great, and the background is simple. I also like the position of the subject. Go ahead and use the Move tool (V) to drag-and-drop this image onto the texture image, then use Free Transform (press Command-T [PC: Ctrl-T]) to scale it to fit, completely covering the texture. Press-and-hold the Shift key as you click-and-drag to keep the image proportional. Press Return (PC: Enter) when done.

©ADOBE STOCK/JEKY CHAN

STEP THREE: Now, open the second texture image. We'll use this one as a texture mask, but first we need to adjust a couple things. Press Command-L (PC: Ctrl-L) to open the Levels dialog. Grab the highlights (white) eyedropper and click it on the lightest gray area in the image to force that shade of gray, and anything lighter, to white. Click OK.

STEP FOUR: Drag-and-drop this texture image onto the main image and make sure the layer is positioned at the top of the layer stack in the Layers panel. Use Free Transform to scale it proportionately to fit in the composition, completely covering the subject. Make sure there is more light area than dark in the visible canvas area, as shown here. Press Return (PC: Enter) when done.

STEP FIVE: Open the Channels panel (Window>Channels) and press-and-hold the Command (PC: Ctrl) key as you click on the RGB thumbnail to load the luminosity of the image as a selection. Once the selection is active, turn off this texture layer's Eye icon (to the left of the layer's thumbnail in the Layers panel) and select the subject layer below.

STEP SIX: Click on the Add Layer Mask icon at the bottom of the Layers panel to add a layer mask to the subject layer and hide the unselected area of the layer, creating an interesting texture effect on the photo. Also, change the layer's blend mode to Multiply to help the rest of the subject blend with the other texture layer below it. Once you do this, it may be necessary to adjust the mask texture. Just click on the layer mask itself to make it active, then open Levels again and adjust the contrast by making the texture lighter, which will reveal more of the masked image. I dragged the Input Levels shadows slider to 7, the midtones slider to 1.38, and the highlights slider to 193.

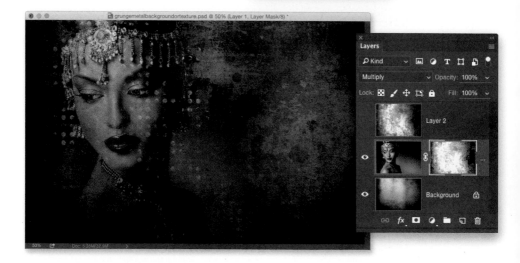

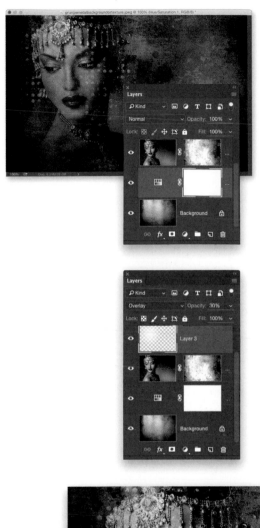

STEP SEVEN: Select the bottom texture layer, then click on the Create New Adjustment Layer icon at the bottom of the Layers panel and choose Hue/Saturation. In the Properties panel, turn on the Colorize checkbox, and then set the Hue to 40 and the Saturation to around 25. This will put a warm cast over the background texture.

STEP EIGHT: Now, the face is still a tad dark, so we are going to fix this with a simple layer trick. Select the subject layer again, then click on the Create a New Layer icon at the bottom of the Layers panel to add a blank layer above it. Press D, then X, to set your Foreground color to white. Select the Gradient tool (G) and, in the Options Bar, click on the gradient thumbnail and choose the Foreground to Transparent gradient. Also, click on the Radial Gradient icon to the right of the gradient thumbnail. Then, click-and-drag from the center of the subject's face outward to add a simple white radial gradient over her face. Change the layer's blend mode to Overlay and drop the layer's Opacity to 30%. Finally, you can use the Horizontal type tool (T) to drop in some text or leave the image as is.

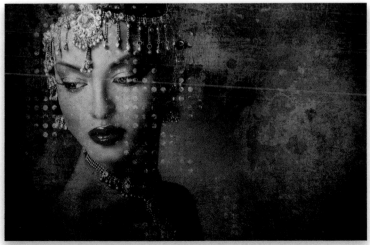

Final

I use this technique quite often when I need a quick rain or snow effect. It is really easy and once you have it created and saved it into Photoshop as a defined pattern, you can have it on call whenever you need it.

STEP ONE: We will start with rain. Press Command-N (PC: Ctrl-N) and create a new document that is 2000 pixels by 2000 pixels at 125 ppi. Just set the Background Contents to White.

STEP TWO: Press D set your Foreground and Background colors to their defaults, then go under the Filter menu, under Noise, and choose Add Noise. Set the Amount to the maximum of 400%. Then, set the Distribution to Gaussian and turn on the Monochromatic checkbox. Click OK.

STEP THREE: Go under the Filter menu again, but this time, go under Blur and choose Gaussian Blur. Set the Radius to 1 pixel and click OK. (This is for rain. For snow, you'll set this to 7 pixels, and then go to Step Seven.)

STEP FOUR: Go under the Filter menu once more, and this time, go under Stylize and choose Wind. Set the Method to Wind and the Direction to From the Left. Click OK.

STEP FIVE: Reapply the Wind filter by pressing Command-F (PC: Ctrl-F). Do this 8–10 more times to build the stylized wind effect.

STEP SIX: Then, go under the Image menu, under Image Rotation, and choose 90° Counter Clockwise. Now the rain is upright.

STEP SEVEN: Press Command-L (PC: Ctrl-L) to open the Levels dialog. Grab the shadows (black) eyedropper below the Options button, and click anywhere in the image (preferably in a lighter gray area, but I blindly clicked on the image several different times and got the same result). Instantly, you will see the rain appear.

It still may be a bit much, so push the shadows and highlights Input Levels sliders in a little bit to increase the contrast and thus lessen the amount of rain: push the shadows slider in to lessen the overall rain, and then push the highlights slider in just a little bit to lighten what is left. Here, I set shadows to 61, midtones to 0.68, and highlights to 232.

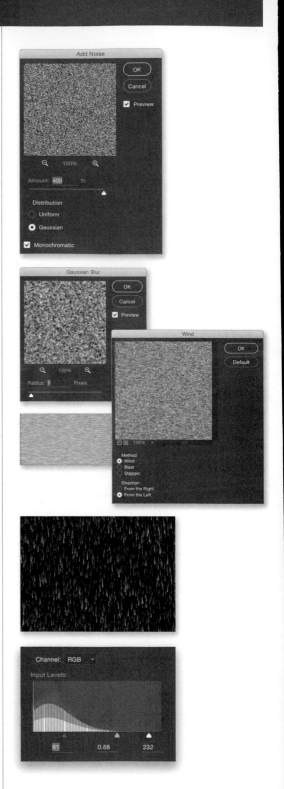

Note: For snow, you can just push the shadows and highlights Input Levels sliders inward until you get the amount of snow you want. Click OK. Then, go under the Filter menu, under Other, and choose Offset. Set the Horizontal and Vertical to where you have the edges centered like crosshairs.

Now get the Patch tool from the Toolbox, and with the sampling set to Content Aware in the Options Bar, select the lines and drag to another part of the image to fill it until the lines are gone. Now go on to Step Eight.

STEP EIGHT: Go to the Layers panel, and click-and-drag the Lock icon on the Background layer onto the Trash icon to unlock the layer. Press Command-T (PC: Ctrl-T) to activate Free Transform, and then go to the Options Bar and set the rotate angle to 10 degrees. Next, go to the scale settings to the left, and click on the chain icon to link them. Then, set one of the settings to 125% and the other will set automatically. This will scale it to fill the canvas area. Press Return (PC: Enter) when done.

STEP NINE: Go under the Edit menu and choose Define Pattern. Then, name the pattern when prompted and click OK.

STEP 10: Now, just open a design or photo you want to add the effect to. Then, click on the Create a New Layer icon at the bottom of the Layers panel, press Shift-Delete (PC: Shift-Backspace) to open the Fill dialog, and choose 50% Gray from the Contents pop-up menu to fill it with a base color. Click on the Add a Layer Style icon at the bottom of the Layers panel and choose Pattern Overlay. Click on the Pattern thumbnail to open the Pattern Picker, and locate the defined pattern (it should be the last one). Then, set the Blend Mode to Screen and drop the Opacity to 75%.

Here is the best part: you can scale the pattern for rain that appears to be closer or farther away. Here I am starting with it at 150%. Do not click OK yet.

STEP 11: The base color of the layer is still obstructing it, so click on Blending Options on the left and set the Fill Opacity under Advanced Blending to 0%.

While you have the Layer Style dialog open, you can click on the rain pattern directly in the image and manually move it around to reposition it. Now that you can see the rain on the image, you can go back and make any adjustments to the other settings if needed. In fact, I encourage you to try different settings to see what they do. Click OK when done.

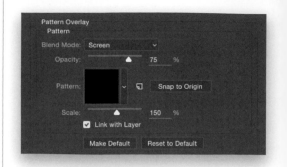

Final

Let's explore one of the companion mobile apps for the Creative Cloud, called Adobe Capture, which you can link to your Creative Cloud account so you can use captured assets, like brushes, in your desktop applications. Here we will turn a simple movie ticket stub into an abstract scatter brush for Photoshop by using a smartphone.

STEP ONE: With the Capture app launched on your smartphone, sign in to your Creative Cloud account and tap Brushes at the top of the screen, then tap the + (plus sign) at the bottom. Position the camera over the graphic or object you want to turn into a brush (I placed the movie ticket stub on a blank piece of paper), then tap on the background to knock it out. Use the slider below to adjust it, so just the text of the ticket is visible.

STEP TWO: Once the image is captured, you can adjust the cropping border to just the graphic area, then tap Next at the top right. You will see a list of different types of brushes you can create. Scroll down until you see Adobe Photoshop CC Brushes. Tap the first brush under this heading, then tap Next again. You will then be able to test the brush. If all looks good, tap Next again, and then tap Save Brush at the bottom of the next screen.

STEP THREE: Now, tap the brush in the Brushes list and tap the place in folder icon at the bottom left of the screen. Here, you will see available libraries in your CC account. Tap on the Brushes library (if you haven't created one in your Photoshop Libraries panel yet, go ahead and create a new one named "Brushes" here in Capture) to save this brush to the cloud, and it will be available when you get started in Photoshop.

TIP: If you do not have Capture, you can take a regular picture of a ticket with your phone, download it to your computer, open it in Photoshop, adjust the contrast with Levels, and then define the brush like normal by going under the Edit menu and choosing Define Brush Preset.

STEP FOUR: Now, open the image of your subject (you can download the one I'm using from the book's downloads page, mentioned in the book's introduction). You can see this image is a simple model shot on a white background. There is good shadow area, and the hair and eyes are nice and dark.

STEP FIVE: Press D to set your Foreground and Background colors to their defaults, and then make the image black and white using the Gradient Map method we used earlier in this chapter by going under the Image menu, under Adjustments, choosing Gradient Map, and clicking OK.

STEP SIX: Next, press Command-I (PC: Ctrl-I) to Invert the image. Then, press Command-L (PC: Ctrl-L) to open the Levels dialog, and boost the contrast by dragging the Input Levels sliders toward the center. Here, I dragged the shadows slider to 18, the highlights slider to 212, and the midtones slider to 0.97 to darken the lighter gray areas and brighten the white areas. Click OK.

STEP SEVEN: Open the Channels panel (Window>Channels), and then Command-click (PC: Ctrl-click) on the RGB channel's thumbnail to load the image brightness as a selection.

STEP EIGHT: Click on the Create a New Layer icon at the bottom of the Layers panel to create a new blank layer, and then click on the Add Layer Mask icon. This will create a layer mask with the selected area in white and the background in black, essentially applying the image to the layer mask.

STEP NINE: Now, create another new layer below this layer by pressing-and-holding the Command (PC: Ctrl) key as you click on the Create a New Layer icon. Press X to set your Foreground Color to white, and then press Option-Delete (PC: Alt-Backspace) to fill this layer with white.

STEP 10: Select the Brush tool (B) in the Toolbox, and then open the Libraries panel (Window>Libraries). Go to the menu at the top and choose the Brushes folder. Your brush should be available at the top of the list.

STEP 11: Open the Brush options panel (Window>Brush) and, in the Brush Tip Shape section, set the Size to 350 px. Then set the Spacing to 135%. Next, click on Shape Dynamics on the left and set the Size Jitter to around 35%, then go to the bottom and turn on the Flip X Jitter and Flip Y Jitter checkboxes.

STEP 12: In the Layers panel, click back on the layer with the layer mask, and make sure the image thumbnail, not the layer mask, is selected. Press X to switch your Foreground Color back to black, and start painting on the layer. The painting will appear through the white area of the layer mask. Just continue to paint to build the effect and reveal the subject.

STEP 13: Now, to add to the effect. Create a new blank layer at the top of the layer stack, and drop its Opacity to 25%. Then, increase the brush Size to around 750 px and paint randomly around the background area, as seen here.

STEP 14: Open a texture image and use the Move tool (V) to drag-and-drop it onto your image of the woman, placing it above the white fill layer in the Layers panel. Press Command-T (PC: Ctrl-T) to open Free Transform and resize it, so it covers the layer. Then, drop the layer's Opacity to around 25%. I just used the same base texture here, from the Blending Textures Through Styles & Masking technique earlier in this chapter.

STEP 15: Finally, select the topmost layer in the Layers panel, then click on the Create New Adjustment Layer icon at the bottom of the panel, and choose Hue/Saturation. Turn on the Colorize checkbox and set the Saturation to around 35. Then, just drag the Hue slider to a color you like and you're done. Pretty cool effect with a simple movie ticket stub, huh?

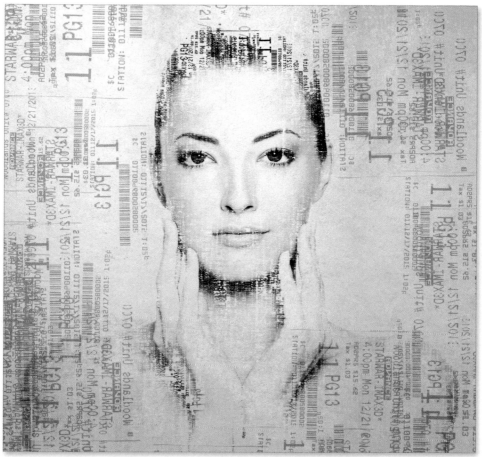

Final

CHAPTER

6

Light Effects

Any photographer will tell you that lighting is one of the key aspects of great photography, if not the main one. You could say the same for design, as well. Utilizing light and shadow with these cool tricks can give your work that extra element.

The Design of Bokeh

The bokeh effect is actually a photography thing where specks of light that are outside the focal range of a photo will have a sort of aesthetic blur to them. Here we will explore how to create a graphic version of that effect that can be used in your own designs.

STEP ONE: Start by pressing Command-N (PC: Ctrl-N) and creating a new document that is 2000 pixels by 2000 pixels at 100 ppi. Set the background to any color you want to use. Here, I am using a blue background.

STEP TWO: Now, choose the Brush tool (B) in the Toolbox, and then open the Brush options panel (Window>Brush). In the panel, click on Brush Tip Shape near the top left and choose a hard, round brush. Set the Size to 750 px and then increase the Spacing to around 225%.

STEP THREE: Next, click on Shape Dynamics on the left. Set the Size Jitter to around 70%.

STEP FOUR: Then, click on Scattering on the left. Turn on the Both Axes checkbox and set the Scatter amount to 240%.

STEP FIVE: Finally, click on Transfer on the left. Set the Opacity Jitter amount to 85%. You can see how this will look in the preview area at the bottom of the panel. Now, click on the Create a New Layer icon at the bottom of the Layers panel to create a new blank layer, and set the layer's blend mode to Overlay.

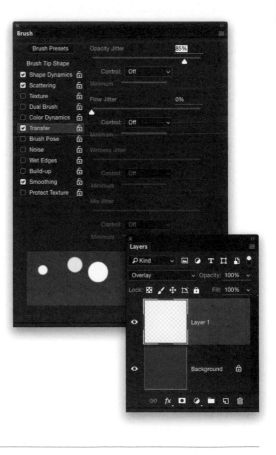

Step 6

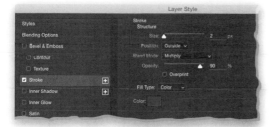

STEP SIX: Press D, then X, to set your Foreground color to white. Now go ahead and start painting some bokeh. You will notice that the size and opacity vary as you paint. This has more of a look of regular bokeh. In fact, if you make the brush size smaller and drop the Hardness in the Brush Tip Shape section, you get a very realistic bokeh effect on a photo. In this case, however, we could use it for a background design element, but let's add one more thing.

STEP SEVEN: Click on the Add a Layer Style icon at the bottom of the Layers panel and choose Stroke. Set the Size to 1 or 2 px and make sure Position is set to Outside. Also, change the Blend Mode to Multiply. Then, click on the Color swatch to open the Color Picker and click on the background color of the image you started with to sample it. Click OK. Lastly, drop the Opacity to 90% and click OK. You can now see an interesting stroke effect appears around the dots. This changes the more you paint in.

Once done, you have a background, and you can create text or drag-and-drop graphics or photos over it, as you see below.

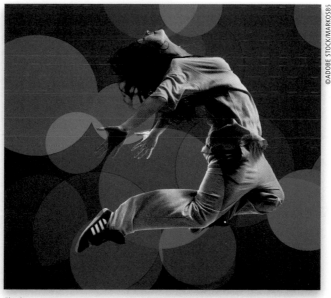

Final

BONUS TIP: Since the brush randomizes the effect differently each time, you can press Command-A (PC: Ctrl-A) to select the entire document, and then paint the effect with different strokes. If you do not get what you like, just press Delete to erase the contents of the top layer, and paint again until you get what you want.

EXTRA BONUS TIP: If you want to save the brush with all the Brush panel settings, just click on the Tool Preset icon at the left end of the Options Bar, then click on the Create New Tool Preset icon (it looks like the Create a New Layer icon) at the top right of the panel. This will save all the properties of the brush, so you can use it whenever you want. You will just need to remember to apply the Stroke layer style to the layer to get that graphic look.

Sparks are a common and cool design element these days, especially in movie posters and such. Here, we will take a look at a couple different ways to use simple spark elements in your own design work.

STEP ONE: Open the sparks image I'm using here (download it from the book's downloads page, mentioned in the book's introduction), or use a sparks image of your own if it is similar to what I am using here.

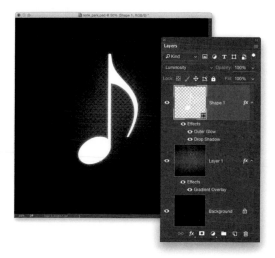

STEP TWO: Next, open the design element you want to add the spark effect to. Here, we have a simple music note graphic on a textured background that I applied a gradient overlay to, like we did in the Blending Graphics with Seamless Textures technique in Chapter 5. This is actually one of the preset shapes from Photoshop's Custom Shape tool. (This file is also available on the book's downloads page.)

STEP THREE: I applied an Outer Glow layer style to the music note, with the Blend Mode set to Linear Dodge (Add), the Opacity to 41%, the Foreground to Transparent gradient's color to orange, and the size to 24 px. I also applied a Drop Shadow layer style to act as a secondary glow on the texture below by setting the Blend Mode to Linear Light, the color to the same orange, the Opacity to 100%, the Distance to 5 px, and the Size to 152 px. This makes the graphic appear more red hot.

STEP FOUR: Now go to the sparks image and use the Move tool (V) to drag-and-drop it over onto the file with the glowing music note. Once the sparks image is placed, scale it to fit in the window using Free Transform (Command-T [PC: Ctrl-T]), and rotate the layer so the sparks are coming in from the bottom, like you see here. Press Return (PC: Enter) when it's where you want it. Make sure the layer is at the top of the layer stack in the Layers panel, then change its blend mode to Screen to hide the black background.

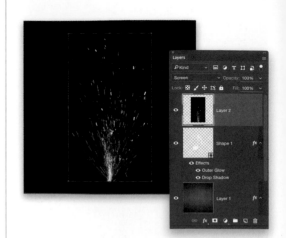

STEP FIVE: Next, go under the Edit menu and choose Puppet Warp. Then, click on the right side of the image, where the sparks enter the frame. This will place a control point. Click in the middle of the sparks to add another, and then on the left side to add a third. (*Note:* I turned off the Show Mesh checkbox in the Options Bar.) If you don't like the placement of a pin, just click on it and press Delete (PC: Backspace) to remove it.

STEP SIX: Now you can grab each control point and manipulate the sparks around the graphic. Also, if you select a control point and then press-and-hold the Option (PC: Alt) key, you will see a rotation guide appear (shown here in the inset). Just keep the Option key held down and move your cursor over the guide and in different directions to change the rotation of the image at that point. If you have never used Puppet Warp, I would suggest playing with the settings a little to get used to them. When it looks good to you, press Return (PC: Enter) to lock in your warp.

STEP SEVEN: Depending on the graphic, you may want to add more sparks: just drag another copy of the sparks into your document and repeat the process as many times as needed.

Below is the same effect applied to some text (using the font Trajan Pro 3 Bold, along with the same layer styles applied to the music note) using multiple copies of the same sparks, but with different warps applied to give each one a unique look. I also added the same spark image in the extreme foreground and gave it a simple 5-px Gaussian Blur (under the Filter menu, under Blur) to add a sense of depth.

BONUS EXAMPLE: Here is another quick example of a cool use of sparks, using an image of embers floating on a black background. We need to first extract these from that background.

STEP ONE: Open the Channels panel (Window>Channels), and you will see from each of the RGB channels that the Red channel obviously has the most detail of the embers. Press-and-hold the Command (PC: Ctrl) key and click on the Red channel thumbnail to load that channel as a selection.

STEP TWO: Go back to the Layers panel and press Command-J (PC: Ctrl-J) to copy the selected area to a new layer.

STEP THREE: Now, if you turn off the Background layer (click on the Eye icon to the left of the layer's thumbnail), you will see that some of the black background was lifted with the embers. There is actually a feature in Photoshop designed to deal with this: go under the Layer menu, to very bottom, to Matting, and choose Remove Black Matte. Voila! All residual black pixels gone.

STEP FOUR: Now, just drag-and-drop the extracted embers onto the image you want to add them to. Position the embers at the bottom of the image, then go under the Edit menu, under Transform, and choose Warp.

STEP FIVE: When the Warp grid appears, use it to push and stretch the sparks to add more chaos to the scene. The stretching also has the added byproduct of giving the embers a subtle motion blur effect. Press Return (PC: Enter) when done. Then, change the blend mode of this layer to Screen. (*Note:* As an option, you can grab the Eraser tool [E] and, using a simple round brush, go around and erase a few random embers to lessen the overall amount.)

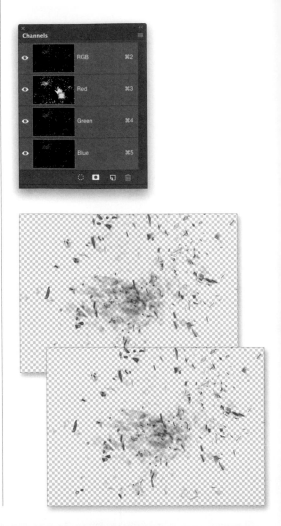

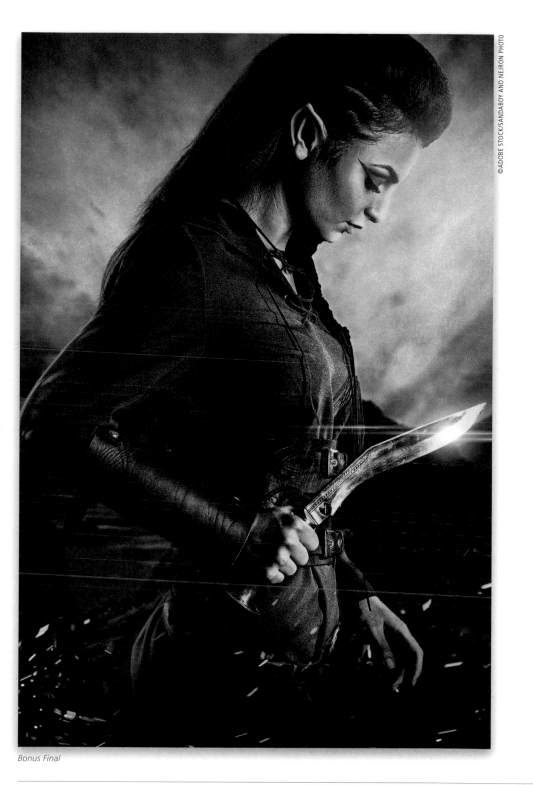

Bonus Final

flare_1.jpg @ 50% (RGB/8#)

©ADOBE STOCK/ELSAR

Flares have quickly become a standard design element in a lot of composite work. Here is a quick way to create a cinematic flare brush, and then another cool little trick you can do with it:

STEP ONE: Open this flare image (you can download it from the book's companion webpage, mentioned in the book's introduction), or use one of your own. You can find lots of flare images by doing a simple Google image search, as well.

STEP TWO: Press Command-Shift-U (PC: Ctrl-Shift-U) to remove the color in the image, and then press Command-I (PC: Ctrl-I) to Invert it.

STEP THREE: Next, open Levels by pressing Command-L (PC: Ctrl-L), then push the white Input Levels (highlights) slider to the left a little to force the background to pure white, just in case there are any barely visible gray areas. Here, I dragged the light gray (midtones) slider a little to the left, as well. Push the dark gray (shadows) slider to the right a little bit to darken the flare, and then click OK.

STEP FOUR: Now, go under the Edit menu and choose Define Brush Preset. Name the brush when prompted, and now you have a flare brush in Photoshop.

STEP FIVE: To use your brush, just open the image you want to add a flare to, get the Brush tool (B), then go to the Brush Picker in the Options Bar and select the brush. Click on the Create a New Layer icon at the bottom of the Layers panel to create a blank layer, and paint in the flare where needed. As an added bonus, you can add an Outer Glow layer style to the flare to get a color effect to match the scene (as you can see reflected on the text in the Final image).

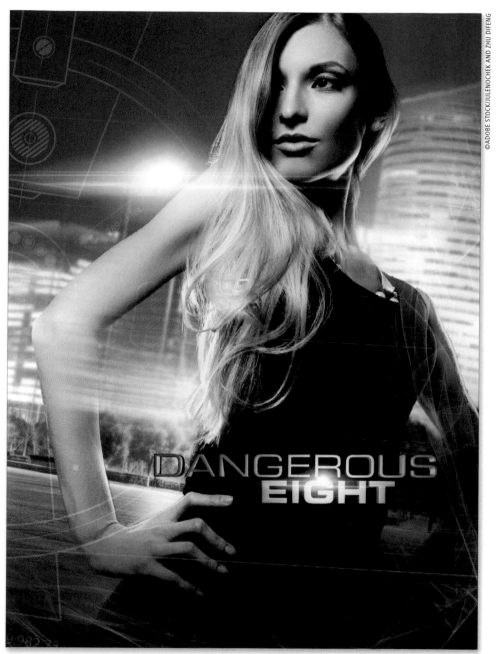

Final

BONUS EXAMPLE: Here is a cool trick you can do with your new flare brush:

STEP ONE: Press Command-N (PC: Ctrl-N) to create a new document that is 2000 pixels by 2000 pixels, and set the Background Contents to black. With the Brush tool (B) active and the flare brush selected, press D, then X to set your Foreground color to white. Create a new blank layer above the Background layer.

STEP TWO: With the brush size at around 1500 pixels, just dab three instances of flares near the bottom edge of the canvas.

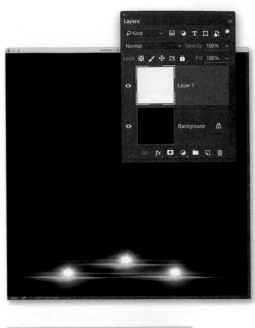

STEP THREE: Then, go under the Filter menu, under Distort, and choose Polar Coordinates. Make sure Rectangular to Polar is turned on, and click OK. This will give you a really cool flare ring.

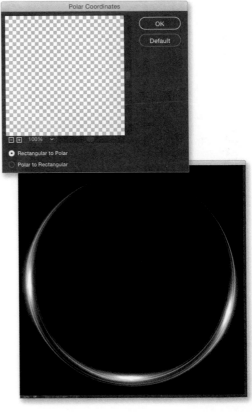

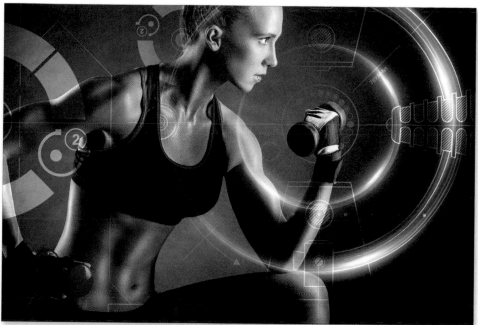

STEP FOUR: Now, just take this ring and add it as part of an image design. Here, I have added it to a sports image, along with the HUD element from Chapter 3 and a Gradient Overlay layer style on the subject layer (like we created in Chapter 5). I also added a cool Outer Glow layer style to the ring layer, like I mentioned earlier. You can use my settings here as a starting point, but they may need to be tweaked based on the image and your preference. I set the Blend Mode to Linear Dodge (Add), the Opacity to 100%, the color to a medium bright blue, and the Size to 210 px.

There are a number of different ways to use this effect once you know how it works. This is a simple example of creating a light streak effect as a design element to help separate parts of an image in an interesting way.

STEP ONE: First, we need to go ahead and set up the layout for the effect. We will start with a photo of a subject. As usual, you can use the image I am using here (you can find it on the book's downloads page, mentioned in the book's introduction) or one of your own.

STEP TWO: Now, press Command-N (PC: Ctrl-N) to create a new document measuring 1350 pixels wide by 2000 pixels tall at 100 ppi. Click on the Background Contents color swatch and fill the Background layer with whatever background color works with the image. Here, I am using a teal color. Then, go ahead and use the Move tool (V) to bring the subject image into this new canvas. Once in place, make a duplicate of your subject layer by pressing Command-J (PC: Ctrl-J), and then turn off the Eye icon (in the Layers panel) for this duplicate layer for the moment.

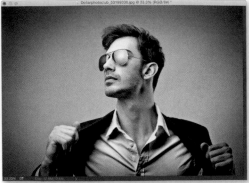

STEP THREE: Click on the original subject layer in the Layers panel and activate Free Transform (press Command-T [PC: Ctrl-T]). Scale this image to almost 200% of its original size, then Right-click on the image while still in Free Transform, and choose Flip Horizontal. Press Return (PC: Enter) to commit the change. Now, press Command-Shift-U (PC: Ctrl-Shift-U) to remove the color, and drop the layer's Opacity to 20%.

STEP FOUR: Click on the Create a New Layer icon at the bottom of the Layers panel to create a blank layer above the enlarged subject layer but below the duplicate layer. Grab the Rectangular Marquee tool (M) and click-and-drag out a narrow vertical rectangle on the canvas. Then, press Shift-Delete (PC: Shift-Backspace) to open the Fill dialog, choose 50% Gray from the Contents pop-up menu, and click OK.

STEP FIVE: Turn the duplicate layer's Eye icon back on and select the layer, then go into Free Transform and resize the image so the subject fills the layer. Press Return (PC: Enter), then press Command-Option-G (PC: Ctrl-Alt-G) to clip the duplicate layer inside the gray rectangle layer. Notice that you can move the shape and the clipped image independently.

STEP SIX: Now, for the light streaks. We will use these to make the edges of the rectangle more interesting. Start by creating a new blank layer at the top of the layer stack, and then selecting the Brush tool (B) in the Toolbox. Click on the brush thumbnail in the Options Bar to open the Brush Picker, and choose a standard round, soft-edged brush. Here, I have the brush around 65 px in size with a Hardness of 0. Open the Brush panel (Window>Brush) and click on Shape Dynamics on the left. In the Size Jitter Control pop-up menu, choose Pen Pressure, even if you are not using a pressure-sensitive tablet.

STEP SEVEN: Get Pen tool (P) in the Toolbox now, and make sure the tool mode near the left end of the Options Bar is set to Path. Start at the top edge of the canvas at the top-left corner of the rectangle and click to start a path. Press-and-hold the Shift key and click at the bottom-left corner of the rectangle to make a straight vertical path along the left edge of the shape.

STEP EIGHT: Open the Paths panel (Window> Paths) and make sure the path layer is selected. Then, click on the top-right corner of the panel and choose Stroke Path from the flyout menu. Choose Brush from the Tool pop-up menu and turn on the Simulate Pressure checkbox. Click OK. This will add a cool light streak along that edge.

STEP NINE: Next use the Path Selection tool (A) to grab the vertical path and drag it to the other side of the rectangle. It should snap to the edge when you get close.

STEP 10: Since you have already applied the brush once to the path, you can just click on the Stroke Path icon (the second from the left) at the bottom of the Paths panel. It remembers the last brush used.

STEP 11: Now, just click on the Add a Layer Style icon at the bottom of the Layers panel and add a simple Outer Glow layer style to get a colored glow, like we did in the last technique. You can also select both the rectangle and streak layers (by Command-clicking [PC: Ctrl-clicking] on each) and skew them (under the Edit menu, under Transform) for a more interesting layout. Always entertain different options when you can.

I also added a Gradient Overlay layer style (using a Foreground-to-Transparent radial gradient) to the background color layer to add some lighting to it so it seemed less flat. To add the layer style, you'll have to double-click on the Background layer, then click OK to unlock it.

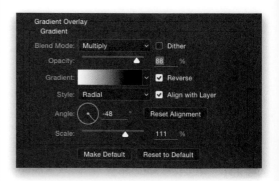

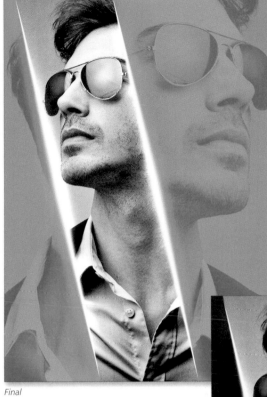

Final

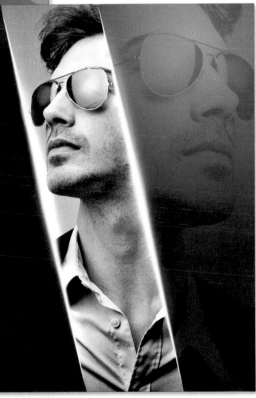

Final with Gradient Overlay layer style added

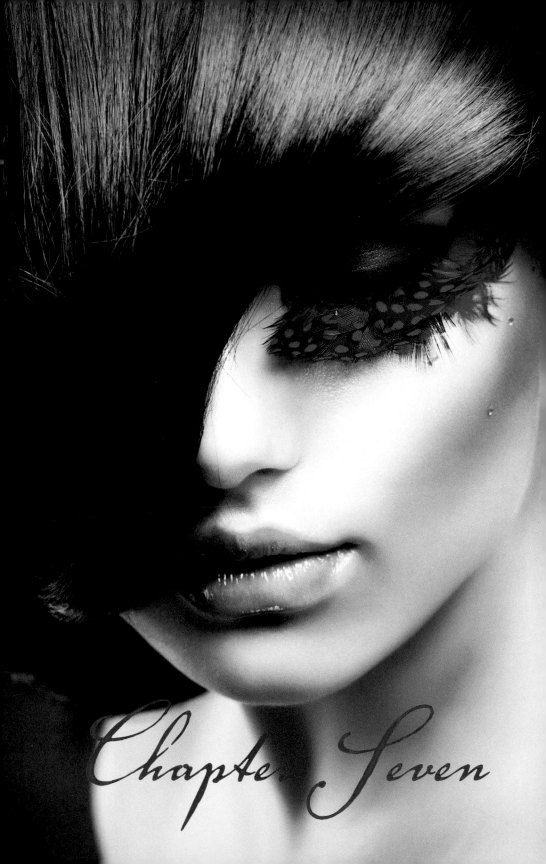

Chapter Seven

Color Effects

I included this chapter on designing with color effects because using the wrong colors alone can kill a good design. Also, understanding how Photoshop uses color can help you get creative with the way you use it in your own work.

This effect can be achieved a number of different ways, but this is the way I use it most often. It uses the color in the original image and the process is non-destructive. It is simple, but in the end has quite an impact.

STEP ONE: Open the image you want to apply the effect to. I like this shot because it emphasizes the jewelry. Let's enhance that by isolating the color to the jewelry, lips, and nails.

STEP TWO: We will use a simple gradient map trick to convert the image to black and white. Just press D to set your Foreground and Background colors to the default black and white, then go to the Layer menu, under New Adjustment Layer, and choose Gradient Map. Click OK in the dialog, and you will see the adjustment layer appear in the Layers panel with a layer mask already applied.

STEP THREE: Choose the Brush tool (B) in the Toolbox, and in the Options Bar, choose a simple, round, soft-edged brush from the Brush Picker. Now, this next step applies to those of you using a pressure-sensitive tablet, like a Wacom. If you are not using one, I encourage you to check them out. If you are, go to the Brush options panel (Window>Brush), click on Transfer on the left, and set the Opacity Jitter Control pop-up menu to Pen Pressure. If you do not have a tablet, you can drop the brush's Opacity in the Options Bar to 10%.

STEP FOUR: Now, paint on the layer mask in the areas you want to hide the gradient map (in other words, reveal the color from the original image). Here, I painted over the jewelry, lips, and fingernails. Using my Wacom pen and the Pen Pressure setting, I just pressed lightly and built the reveal with each passing stroke. Thus, it hints at the color, rather than revealing it 100%. *Note:* You can do the same without Pen Pressure by, again, simply adjusting the Opacity of the brush to 10%, and then each time you click-and-drag over the same place, it reveals a little more.

STEP FIVE: Once the color is revealed, let's boost the contrast of the subject a bit more by adding a Levels adjustment layer (under the Layer menu, under New Adjustment Layer), and then positioning it below the Gradient Map adjustment layer in the Layers panel. Once in place, set this adjustment layer's blend mode to Soft Light.

STEP SIX: In the Properties panel, move the white (highlights) slider below the histogram to the left quite a ways to blow out the whites in the image (here, I dragged it to 185). I also moved the light gray (midtones) and dark gray (shadows) sliders to the right a little (to 1.11 and 5, respectively). This gives it a stylized look.

STEP SEVEN: Finally, just use the Horizontal type tool (T) to drop in some text and you are all set. I used Trajan Pro Regular, and then set the text layer's blend mode to Difference, which made it look like the "L" has some of her hair curled in front of it.

Final

I like to use images I take with my phone in creative ways, because it is the one camera I always have with me. Sometimes I shoot things with specific design uses in mind. This is a shot I took of the Staples Center in Los Angeles. I liked the lines and angles of the building, and thought it would make a cool color background effect.

STEP ONE: Open the image from the book's downloads page (mentioned in the book's introduction), or feel free to use an image of your own. Let's start by removing the color with a gradient map, the same way we did in the last tutorial, only this time go to the Image menu, to Adjustments, and choose Gradient Map to apply it directly to the layer rather than as an adjustment layer. Just click OK in the dialog.

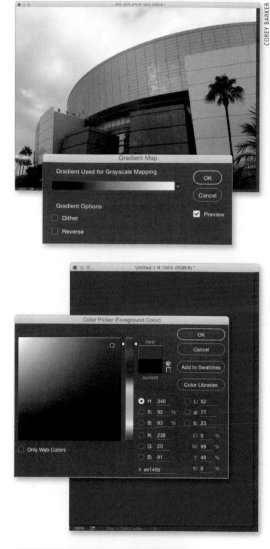

STEP TWO: Now, press Command-N (PC: Ctrl-N) and create a new document that is 1100 pixels wide by 1500 pixels tall at 100 ppi. Click on your Foreground Color swatch at the bottom of the Toolbox, input R=238, G=20, B=91, and click OK. Then, fill the Background layer with this color by pressing Option-Delete (PC: Alt Backspace).

STEP THREE: Go back to your original image, then go to the Image menu again, and under Adjustments, this time choose Levels. We'll use this to increase the contrast. In this case, I dragged the dark gray (shadows) slider to the right and the white (highlights) slider to the left to increase the overall contrast and lighten the sky more. Click OK when you're done.

STEP FOUR: Press Command-I (PC: Ctrl-I) to Invert the image to look like a negative.

STEP FIVE: Open the Channels panel (Window>Channels), and press-and-hold the Command (PC: Ctrl) key as you click on the RGB thumbnail to load the light areas as a selection.

STEP SIX: Back in the Layers panel, click on the Create a New Layer icon at the bottom of the panel, and then choose a bright blue color for your Foreground color (here, I used: R=0, G=0, B=255) and fill the selection with that color by pressing Option-Delete (PC: Alt-Backspace). Press Command-D (PC: Ctrl-D) to Deselect.

STEP SEVEN: Now, use the Move tool (V) to click-and-drag this new layer into the document we created in Step Two. Press Command-T (PC: Ctrl-T) and use Free Transform to scale and position it in the new composition. Here, I enlarged it and rotated it slightly.

STEP EIGHT: Next, go to the Layers panel and change this layer's blend mode to Multiply and its Opacity to 75%.

STEP NINE: Finally, use the Horizontal Type tool (T) to drop some text in, and you're done. Here, I used Eurostile Extended 2 and Bold Extended 2, and added a Drop Shadow layer style. All from an iPhone image.

Here is another example, using another iPhone shot I took in my car. See how getting creative with color can make you look at images in a whole new way, even seemingly bad ones?

Final

Final

Here is a cool commercial effect you can use on products. It utilizes simple color bars to create an interesting layout, and then blend modes to blend the product with the background.

STEP ONE: Press Command-N (PC: Ctrl-N) and create a new document measuring 2000 pixels wide by 1000 pixels tall at 100 ppi. Then, press Shift-Delete (PC: Shift-Backspace) and, in the Fill dialog, choose 50% Gray from the Contents pop-up menu and click OK. Press Command-R (PC: Ctrl-R) to make the rulers visible. Then, click in the vertical ruler, drag out a guide, and place it at the 500-pixel mark on the horizontal ruler. Place two more guides at the 1000- and 1500-pixel marks.

STEP TWO: Go to the Toolbox and select the Rectangle shape tool (U). In the Options Bar, set the tool's mode to Shape and set the Stroke color to none. Click on the Fill swatch, then click on the rainbow-colored swatch at the top right of the Color Picker, and set the color to the green color I am using here (R=57, G=181, B=74). Click OK.

STEP THREE: Now, click on the first guide, just above the canvas edge, and draw a green rectangular shape over the entire first section. This will also create a shape layer automatically.

STEP FOUR: Next, draw a rectangle over the next section defined by the guides. Each new shape will create a new shape layer. The shapes should snap to the guides when you get close to them. If not, go under the View menu and make sure Snap is turned on.

STEP FIVE: Double-click on the second shape layer's thumbnail to open the Color Picker. Set the RGB numbers to R=0, G=114, B=188 for a middle blue color. Click OK.

STEP SIX: Create another rectangle shape over the next area between the guides and change the color to orange (R=248, G=148, B=29).

STEP SEVEN: Create the final rectangle shape at the right end of your document, and fill it with black.

STEP EIGHT: Click on the topmost shape layer in the Layers panel, then Shift-click on the bottom shape layer to select all four, and press Command-T (PC: Ctrl-T) to activate Free Transform. Right-click on one of the shapes and choose Skew from the pop-up menu.

STEP NINE: Press-and-hold the Option (PC: Alt) key, click on the top-middle control handle, and drag it to the right. Skew the shape to around –20 degrees, and press Return (PC: Enter) when you're done. Click OK in the warning dialog that appears.

©ADOBE STOCK/DESTINA

STEP 10: Now, we have areas by the green and black rectangles revealing the gray background. So, choose the Direct Selection tool (the white arrow; press Shift-A until you have it) from the Toolbox.

STEP 11: Click on the green shape layer in the Layers panel, and use this tool to grab the top-left control handle of the shape, then drag it over to the left to cover the rest of the corner. Do the same with the black shape layer to cover the lower-right corner.

STEP 12: Next, press Command-O (PC: Ctrl-O) and open the product image. In this case, we are creating a fake headphone ad, so we have a nice headphone image here. First, we need to extract it from the background. So, select the Quick Selection tool (W) from the Toolbox, and click-and-drag around the white area surrounding the headphones. Don't forget the area in the middle of the headphones. Once you have that, go under the Select menu and choose Inverse (or press Command-Shift-I [PC: Ctrl-Shift-I]) to flip the selection to the headphones.

STEP 13: Click on Refine Edge in the Options Bar. Then, use the Refine Radius tool (to the left of the Edge Detection section) to paint over the bottom area where it touches the surface to select some of the shadows. When your selection is done, set the Output To pop-up menu to New Layer and click OK.

STEP 14: Go under the Layer menu, under Matting, and choose Defringe. Set the Width to 2 pixels and click OK. This will clean up the anti-alias noise around the edge.

STEP 15: We don't need the headphones in color, so remove it by pressing Command-Shift-U (PC: Ctrl-Shift-U). This will leave the contrast a little softer than the gradient map method.

STEP 16: Now, switch back to the color bar image and click on the top layer in the Layers panel to make it active. Use the Move tool (V) to drag-and-drop the headphones onto the color bar image. Then, press Command-T (PC: Ctrl-T) to use Free Transform to scale the headphones to cover the first three color bars like you see here. Press Return (PC: Enter) when you've got them the way you want them.

STEP 17: Change the blend mode of this layer to Difference and drop the layer's Opacity to 75%. Magically, the color effect takes shape.

STEP 18: Go back to the headphone image and drag-and-drop another copy of the headphones over onto the color bar image. Then, use Free Transform again to scale this one down to fit in the black bar area. Also, while in Free Transform, Right-click on the headphones and choose Flip Horizontal and then move your cursor just outside the bounding box and rotate them a little bit. Press Return (PC: Enter) when you're done.

STEP 19: Now, press Commend-L (PC: Ctrl-L) to run a Levels adjustment using the settings I have here (drag the highlights slider to 230, the midtones slider to 0.60, and the shadows slider to 59) to get more contrast in the image against the black background.

Finally, just use the Horizontal Type tool (T) to drop in some text (I used the font Futura Light here), or add a logo, and there you have it.

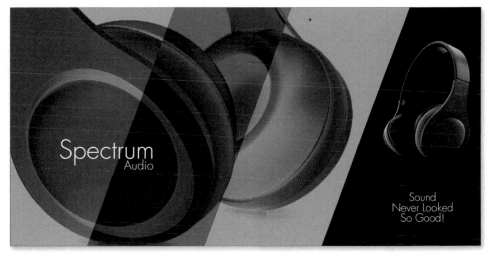

Final

I love brushes in Photoshop! They can be a designers best weapon and can be used in so many different ways. Here we will define a photo of a dancer into a brush and then use the brush features to create an interesting color blend effect.

STEP ONE: To start, we of course need a photo of the subject. It's best if you can get the subject on a white background like this. If not, you will need to extract the subject and then make the background white. Here, we have a dancer in a cool mid-air pose. This image is 2000 pixels by 2000 pixels.

STEP TWO: Go ahead and remove the color using a gradient map by pressing D to set your Foreground and Background colors to their defaults, then go under the Image menu, under Adjustments, and choose Gradient Map. Click OK when the dialog appears.

STEP THREE: Now, go under the Edit menu, choose Define Brush Preset, and then name the brush when prompted. Click OK, and then you can close the image.

STEP FOUR: Select the Brush tool (B) in the Toolbox, then click on the Brush thumbnail in the Options Bar to open the Brush Picker and make sure this new brush is selected (it should be the last one). Next, open the Brush options panel (Window>Brush). Select Brush Tip Shape on the left, and set the brush Size to around 1600 px and the Spacing to 150%.

STEP FIVE: Click on Shape Dynamics on the left. Set the Size Jitter to 75% and the Angle Jitter to 100%.

STEP SIX: Click on Transfer on the left. Set the Opacity Jitter to 50%.

STEP SEVEN: Finally, click on Color Dynamics on the left, and set the Hue Jitter and the Purity to 100%. (*Note:* You can experiment with lower settings once you see how this effect works.)

Final

STEP EIGHT: Here, I am using a parchment texture for the background, which you can download from the book's downloads page, as well. Once open, click on the Create a New Layer icon at the bottom of the Layers panel to create a blank layer. Then, you need to set the Foreground color to a color (Hue Jitter will not work with white or black), so click on its swatch at the bottom of the Toolbox, choose a color in the Color Picker, and click OK. *Note:* The color you start with does affect the colors you see, so try different ones.

BONUS TIP: You can save the brush and all its properties by saving it as a Tool Preset. Click on the very first icon in the Options Bar to access the Tool Preset menu, and then click on the Create New Tool Preset icon (it looks like the Create a New Layer icon). Name it, and it saves all the settings, including the current color if you want. Click OK when done.

STEP NINE: Once you have a color chosen, start painting on the blank layer. Here, I started roughly in the middle and then moved outward in a spiral. You get a different color arrangement and distribution every time you click, so you can undo and paint again several times until you get something you like.

Finally, change the layer's blend mode to Multiply, so it will blend with the texture below. You can leave this as-is or add some text.

Of course I had to throw in a little Hollywood, as well. This is a trick I see in movie posters a lot. It is compositing a scene with a monochromatic background to focus attention more on the main subject, who is in color. Basically, it's drawing attention with color.

STEP ONE: Here, I have a nice shot of a woman in a warrior costume. She is shot on a white backdrop, which makes her easier to select. So much so, in fact, that we will use the Magic Wand tool (Shift-W) this time. Use the default Tolerance of 32 in the Options Bar, and then click on the white background to select it. Don't worry too much about the area around her feet because we're not going to see them anyway, but do make sure that the areas inside the loop at the end of the axe handle and the areas by her head are selected. Just press-and-hold the Shift key as you click in these areas to add them to the selection.

STEP TWO: When done, press Command-Shift-I (PC: Ctrl-Shift-I) to Inverse the selection. Then, click Refine Edge in the Options Bar, and use the Refine Radius tool (to the left of Edge Detection) to adjust the areas around her hair and any other soft edge areas by painting over them. Set the Edge Detection Radius to 0.5 px. Lastly, set the Output To pop-up menu to New Layer with Layer Mask and click OK.

STEP THREE: Now, press Command-N (PC: Ctrl-N) and create a new document that is 1350 pixels by 2000 pixels, and make sure the background is white.

STEP FOUR: Get the Move tool (V) from the Toolbox, and drag-and-drop the extracted subject layer over onto this new document. Then, use Free Transform (Command-T [PC: Ctrl-T]) to scale and rotate the subject to a more interesting angle, like you see here. Press Return (PC: Enter) when done.

STEP FIVE: Next, we need the background element. Here, we have a nice generic winter forest scene. It is in color, which we do not need in this case, so just press Command-Shift-U (PC: Ctrl-Shift-U) to desaturate the image.

STEP SIX: Now, use the Move tool to bring this image into the main layout and position this layer below the subject layer in the Layers panel. Go into Free Transform and resize and rotate the image to a similar angle as the subject, then grab the left and right middle control handles and basically squeeze the image to fit in the composition. Press Return (PC: Enter) when you're done. Drop the layer's Opacity to 90%.

STEP SEVEN: Click on the Create New Adjustment Layer icon at the bottom of the Layers panel and choose Levels. In the Properties panel, below the histogram, drag the center gray midpoint slider to 2.31 and the white highlights slider to 253, then drag the gray shadows Output Levels slider to 22, like I have here to lighten the background.

STEP EIGHT: Click back on the forest layer, and then click on the Create a New Layer icon at the bottom of the Layers panel to add a new blank layer above it. Press D to set your Foreground color to black, and select the Gradient tool (G) in the Toolbox. In the Options Bar, click on the thumbnail gradient and choose the Foreground to Transparent gradient in the Gradient Picker, and then click on the Linear Gradient icon (to the right of the gradient thumbnail). Click-and-drag out a simple black-to-transparent linear gradient at the bottom of the image.

STEP NINE: Now click on the Levels adjustment layer in the Layers panel, and then add a Hue/Saturation adjustment layer. In the Properties panel, turn on the Colorize checkbox. Set the Hue to 204 and the Saturation to 30. This will give the background a monochromatic blue color and will also lighten it. Visually this diminishes the background to a single tone, focusing attention on the subject. However, we do want the subject to blend into the scene a bit more.

STEP 10: Press-and-hold the Option (PC: Alt) key, go under the Image menu, and choose Duplicate to create an instant copy of the file. Create a new blank layer and place it just below the subject layer in the layer stack. Press Shift-Delete (PC: Shift-Backspace) to open the Fill dialog, choose 50% Gray from the Contents pop-up menu, and click OK. Then, go under the Layer menu and choose Flatten Image.

STEP 11: You should only see the subject on a gray background. Go under Image menu, under Adjustments, and choose HDR Toning. Start by setting the Saturation to –100%. This will give you a high-contrast, grittier version. Then, set the Edge Glow Radius to 36 px, the Edge Glow Strength to 0.63, the Exposure to –0.68, and the Detail to 149%, and click OK.

STEP 12: Now, drag-and-drop this new HDR toned layer back onto the original image. Press-and-hold the Shift key as you drop it, so it lands centered and aligned. Place the layer above the original subject layer in the layer stack and press Command-Option-G (PC: Ctrl-Alt-G) to clip this layer to the layer below. Change the layer's blend mode to Multiply and drop its Opacity to around 75%.

STEP 13: Press Command-U (PC: Ctrl-U) to open the Hue/Saturation dialog. Turn on the Colorize checkbox, and set the Hue to 221, Saturation to 45, and the Lightness to +21. This will apply a blue cast to the HDR, which results in a cool overlay to help it match the cool atmosphere surrounding the subject and helping her blend a little better. Click OK when you're done.

STEP 14: Select the main, extracted subject layer in the Layers panel, and press Command-U (PC: Ctrl-U) to open the Hue/Saturation dialog again. This time, drop the Saturation to –15 and click OK to make the subject less warm.

STEP 15: Add a new blank layer at the top of the layer stack, and select the Gradient tool again with a Foreground to Transparent linear gradient. Press-and-hold the Option (PC: Alt) key to temporarily activate the Eyedropper tool and click on a dark blue spot on the background to make that your Foreground color (make sure the Eyedropper tool is set to Sample All Layers in the Options Bar). Then, add a gradient at the bottom to add a dark fade.

STEP 16: Now add another blank layer, press D, then X, to change your Foreground color to white, click on the Radial Gradient icon, and add a white radial gradient in the top-left corner to add a light flare. Bring it over the subject a little bit to blend her in the scene a bit more.

STEP 17: Select the forest layer, then go under the Filter menu, under Blur, and choose Gaussian Blur. Set the Radius to around 2 pixels and click OK. This will create a subtle sense of depth of field.

Finally, I added the quick snow effect that we created in Chapter 5.

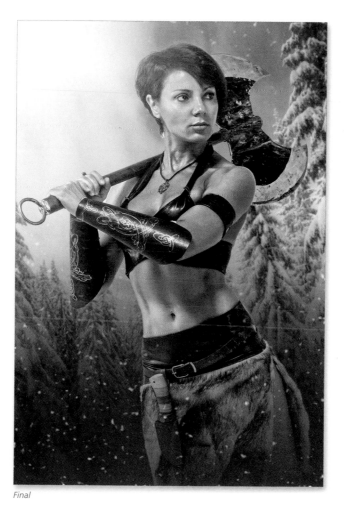

Final

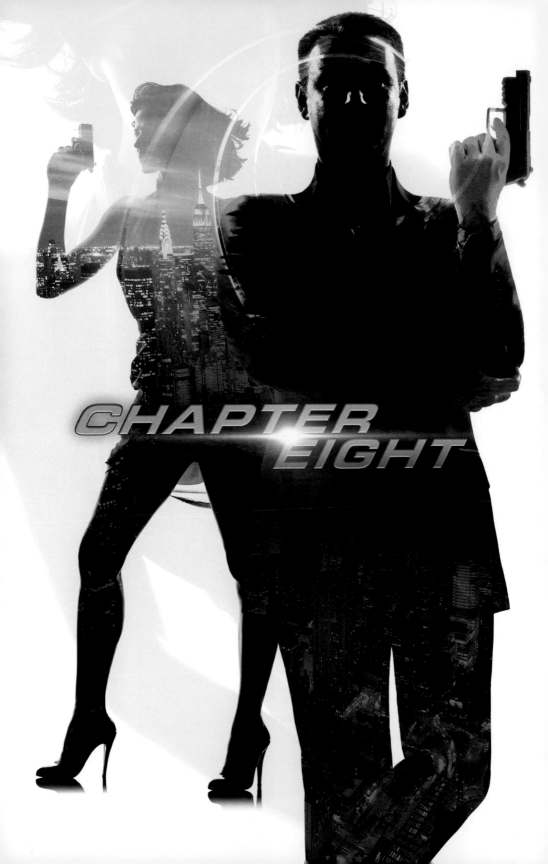

Hollywood-Style Effects

Are you really surprised that I included a Hollywood-Style Effects chapter in this book? Entertainment design has been a big influence for me, and I get a lot of inspiration from it. While not all of us are designing for movies or other entertainment, we can take what we learn and apply it to our own work to get that Hollywood look.

This effect is used quite often in movie ads, as well as in commercial product advertising. It uses the shape of a subject to create a silhouette frame to then composite elements in and around. The result is pretty impressive and can be used in a number of different ways. Once you have this technique down, try experimenting with other shapes.

STEP ONE: It's best to start with a subject that is on a solid background (preferably white), so you can easily extract them. The one we're using here looks like it's right out of an action movie and should be pretty easy to extract (you can, of course, download this from the book's companion webpage, mentioned in the book's introduction).

STEP TWO: Open the Channels panel (Windows>Channels), then press-and-hold the Command (PC: Ctrl) key and click on the RGB thumbnail to load the luminosity as a selection. Since this selects the background, press Command-Shift-I (PC: Ctrl-Shift-I) to Inverse the selection to the subject. Press Command-J (PC: Ctrl-J) to copy the selected area to a new layer, then click on the Eye icon to the left of the Background layer to turn it off.

STEP THREE: Press Command-J (PC: Ctrl-J) four more times to build the density back into the transparent areas. Then, Shift-click on Layer 1 to select all the layers, except the Background layer, and press Command-E (PC: Ctrl-E) to merge them together into one layer. Now, go under the Layer menu, under Matting, and choose Defringe. Set it to 2 pixels and click OK.

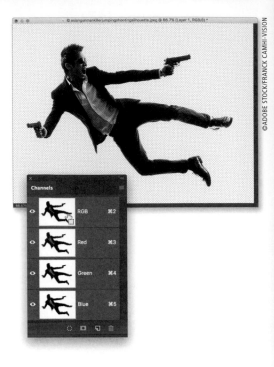

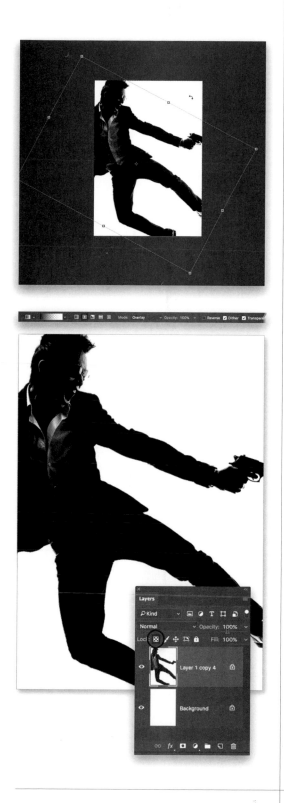

STEP FOUR: Next, press Command-N (PC: Ctrl-N) and create a new document measuring 1400 pixels wide by 2000 pixels tall, with the Background Contents set to White. Using the Move tool (V), click-and-drag the extracted subject into this new document. Press Command-T (PC: Ctrl-T) to activate Free Transform, then press-and-hold the Shift key (to keep things proportional), and scale and position the subject in a dramatic way within the composition. Here, I'm concentrating on the vertical space from his right knee up to his head. That area is where we will clip in another image. Press Return (PC: Enter) when done.

STEP FIVE: Select the Gradient tool (G) in the Toolbox, and then press D to set your Foreground color to black. In the Options Bar, click on the gradient thumbnail and choose the Foreground to Transparent gradient from the Gradient Picker, then click on the Radial Gradient icon to the right of the gradient thumbnail, and set the tool's blend Mode to Overlay. In the Layers panel, click on the Lock Transparent Pixels icon (the checkered box above the top layer's thumbnail) to lock the layer's transparency, and then click-and-drag out a few gradients in the legs and lower torso area to black out the detail.

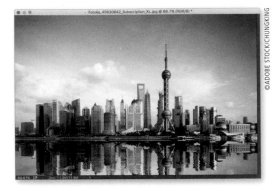

©ADOBE STOCK/CHUNGKING

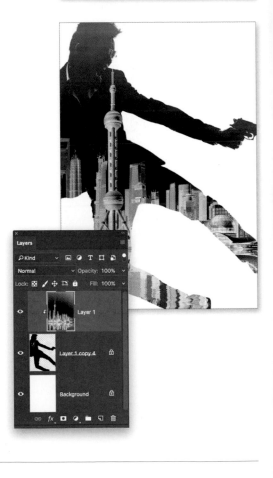

STEP SIX: Next, open the city image you want to blend within the subject. Here's a cool shot of Shanghai that I've used numerous times. Go ahead and drag-and-drop it into the working document and place this layer on top of the subject layer. Then, use Free Transform to scale and position it, so the tower is in the area of the subject I mentioned in Step Four. Once in place, press Command-Option-G (PC: Ctrl-Alt-G) to clip this layer inside the subject layer below it.

STEP SEVEN: Press Command-Shift-U (PC: Ctrl-Shift-U) to remove the color, and then press Command-I (PC: Ctrl-I) to Invert the tones.

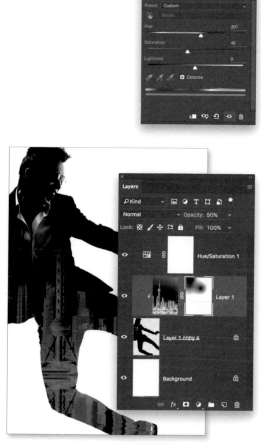

STEP EIGHT: Click on the Create New Adjustment Layer icon at the bottom of the Layers panel and choose Hue/Saturation (be sure this adjustment layer is at the top of the layer stack). In the Properties panel, turn on the Colorize checkbox and then set the Hue to around 200 and the Saturation to around 40.

STEP NINE: Select the inverted city layer in the Layers panel and drop its layer Opacity to 50%. Click on the Add Layer Mask icon at the bottom of the panel, then switch back to the Gradient tool, set its blend Mode to Normal (leave the other settings as is), and add a couple gradients around the subject's face and upper torso area.

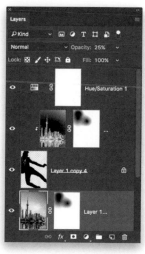

STEP 10: Now, make a duplicate of the city layer with its layer mask, and then position it beneath the main subject layer. Make sure the image thumbnail is selected, then Invert the city image, again, to put it back to normal, and drop the layer Opacity to 25%. This will pick up the color from the Hue/Saturation adjustment layer.

STEP 11: Remember the HUD graphic element from Chapter 3? We're going to add that here. Click on the Create a New Layer icon at the bottom of the Layers panel to create a new blank layer, and then move that layer beneath the Hue/Saturation adjustment layer at the top of the layer stack. Press Shift-Delete (PC: Shift-Backspace) to open the Fill dialog, choose 50% Gray from the Contents pop-up menu, and click OK.

STEP 12: Now, click on the Add a Layer Style icon at the bottom of the Layers panel and choose Pattern Overlay. Click on the Pattern thumbnail and find your HUD graphic pattern, then set the Blend Mode to Difference, and position the graphic manually (just click outside the Layer Style dialog, and drag it around in your image). Then, select Blending Options on the left, set the Opacity to 25%, and drop the Fill Opacity to 0, so the HUD will blend with the image. Click OK.

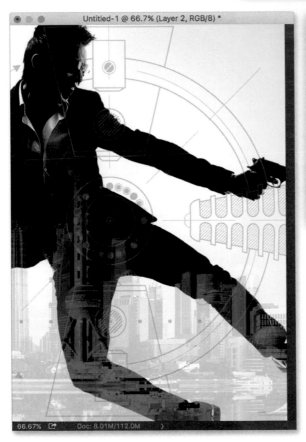

STEP 13: Finally, add a layer mask to this layer and use the radial Gradient tool, again, to add some fades to the HUD graphic in the areas where needed. Then, just drop in some text (I used the font Eurostile Bold Extended Two), with a little flare magic (see Chapter 6), and you are done.

Final

Now this effect should probably be in the commercial chapter, but I finished that chapter a while back, and it does qualify as a Hollywood effect. It is a cool way of taking a simple photo, even one from your phone, and making it look like something you would see in a poster frame.

STEP ONE: Here, we have a nicely timed shot of a biker mid-jump (which you can download from the book's companion webpage, mentioned in the book's introduction). The background is subtle enough to get a good selection of the subject, so open the Channels panel (Window>Channels) and click on the Blue channel since that's where the biker has the most contrast from the background. Make a duplicate of it by dragging it onto the Create New Channel icon at the bottom of the panel.

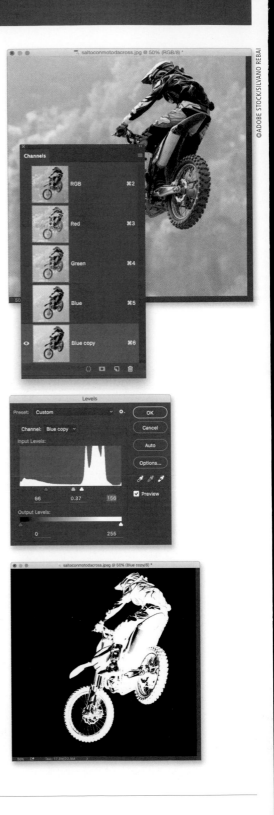

STEP TWO: With the duplicate channel se-lected, press Command-L (PC: Ctrl-L) to open Levels. Click on the white (highlights) eyedropper, beneath the Options button, and click on a light area to the left of the subject to force the background to white. Continue clicking on any other areas in the background that are still gray to force them to white. Then, adjust the sliders beneath the histogram to boost the overall contrast of the channel (here, I set the shadows [dark gray slider] to 66, the midtones [light gray slider] to 0.37, and the highlights [white slider] to 156). Click OK when done.

STEP THREE: Press Command-I (PC: Ctrl-I) to Invert the channel, making the subject white. Don't worry about the areas that are still black—we don't need a full selection here.

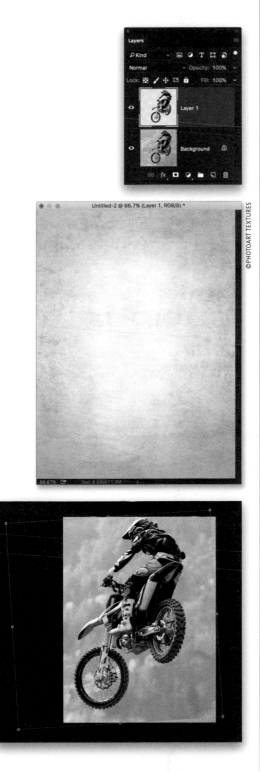

©PHOTOART TEXTURES

STEP FOUR: Next, Command-click (PC: Ctrl-click) on the Blue Copy channel thumbnail to load it as a selection, then click on the RGB channel and press Command-J (PC: Ctrl-J) to copy the selection to a new layer.

STEP FIVE: Press Command-N (PC: Ctrl-N) and create a new document measuring 1500 pixels wide by 2000 pixels tall, with the Background Contents set to White. Then, press Command-O (PC: Ctrl-O) and open the background texture image. Notice what we're using here is a light texture with subtle detail (if you want to use your own texture). Using the Move tool (V), drag-and-drop this texture into your new document.

STEP SIX: Go back to the subject file, Shift-click to select both the Background layer and the extracted subject layer, and drag-and-drop them both onto the texture image. With both still selected, press Command-T (PC: Ctrl-T) to activate Free Transform, press-and-hold the Shift key (to keep things proportional; press Command-0 [zero; PC: Ctrl-0] to reach the control handles), and then scale and position both of them together, so they stay aligned. Once in place, press Return (PC: Enter).

STEP SEVEN: Click on the Eye icon to the left of the extracted subject layer to turn it off. Then, select the original subject layer, set its blend mode to Linear Burn, and drop its Opacity to 80%. Now, press-and-hold the Option (PC: Alt) key and click on the Add Layer Mask icon at the bottom of the Layers panel to add a Hide All (black) layer mask.

STEP EIGHT: We're now going to use a brush, which I've also made available for you to download on the book's companion web-page. Once you've downloaded it, get the Brush tool (B), then click on the brush thumbnail in the Options Bar and, in the Brush Picker, click on the gear icon in the top right. Choose Load Brushes from the pop-up menu, find the brush, and click Open. It'll now appear at the bottom of the Brush Picker. Click on it, and then open the Brush options panel (Window>Brush). Set the Size to around 1400 px and the Spacing to 50%, then click on Shape Dynamics on the left and set the Angle Jitter to 100%.

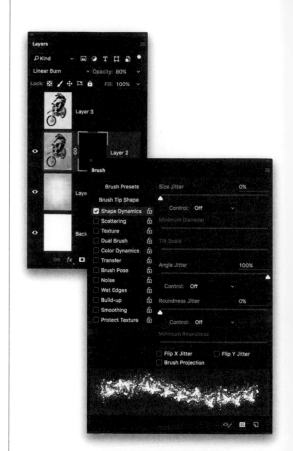

STEP NINE: Turn the extracted subject layer back on and make sure the layer mask on the layer below is still selected. Press D to set your Foreground color to white, and then dab a few spatters on the layer mask to reveal the original image.

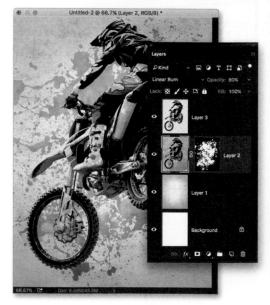

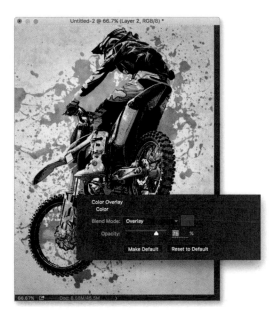

STEP 10: Let's add some color to these spatters. Click on the Add a Layer Style icon at the bottom of the Layers panel and choose Color Overlay. Then, click on the color swatch, choose a blue color in the Color Picker, set the Blend Mode to Overlay, and drop the Opacity to 75%. Click OK.

STEP 11: Select the extracted subject layer, then go under the Filter menu, and choose Filter Gallery. In the dialog, under Artistic, choose Poster Edges. Set all three sliders on the right to 2 and click OK.

(*Note:* To see the Filter Gallery filters in the Filter menu, open Photoshop's Preferences and, on the Plug-Ins tab, turn on the Show All Filter Gallery Groups and Names checkbox.)

STEP 12: Now, press Command-U (Ctrl-U) to open the Hue/Saturation dialog and move the Hue slider around to change the color range of the subject. Below, I set it to –35. Click OK.

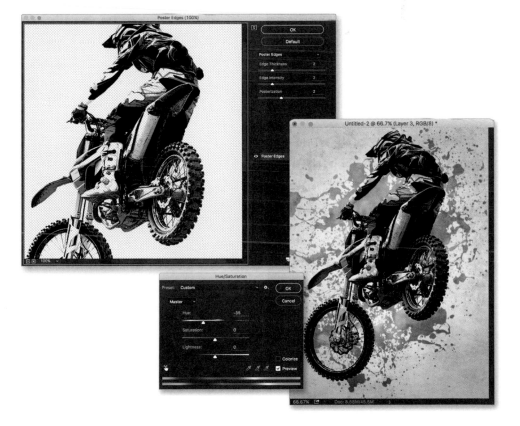

STEP 13: As an option, you can add a gradient overlay to the texture layer. Just select it in the Layers panel, then click on the Add a Layer Style icon and choose Gradient Overlay. Set the Blend Mode to Overlay, the Opacity to 75%, and the Style to Radial. Set the Scale to around 100%, then adjust the Angle a bit, and move it manually towards the bottom right of the image. This will help give it a subtle vignette effect. Click OK.

STEP 14: Let's now add a simple blue oval beneath the bike. Get the Elliptical Marquee tool (press Shift-M until you have it) from the Toolbox and click-and-drag to create an oval down by the tires. Click on the Create a New Layer icon at the bottom of the Layers panel to put this oval on its own layer, then press Shift-Delete (PC: Shift-Backspace) to open the Fill dialog. Choose Color from the Contents pop-up menu, and then choose a darker blue color from the Color Picker. Click OK in both dialogs. Now, press Command-T (PC: Ctrl-T) to activate Free Transform and scale and position it like I have here. Press Return (PC: Enter), and then drop the layer's Opacity to 75% and set its blend mode to Linear Burn. Press Command-D (PC: Ctrl-D) to Deselect.

STEP 15: Click on the Add Layer Mask icon, then get the Brush tool again and, with a black, soft-edged round brush, click on the area of the oval beneath the bike, so that it blends better. Let's also let the texture show through some more, by clicking on the Add a Layer Style icon and choosing Blending Options. Press-and-hold the Option (PC: Alt) key, click on the gray Underlying Layer slider knob, and drag to the right to split it. Do the same with the white slider knob, but click-and-drag to the left.

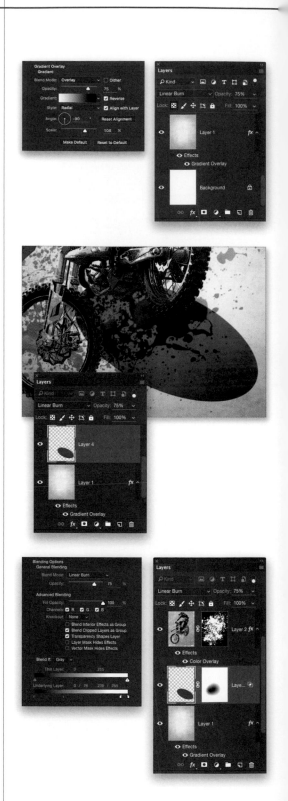

Lastly, just add some text. Here, I have "The Grind" in a cool font, called Hard Grunge. I filled it with an orange color sampled from the orange color patch in the bike, set the layer blend mode to Difference, and added a simple Drop Shadow layer style to make it more readable.

Final

This effect, it seems, has been used numerous times for many films. In fact, I have even seen many use the same backdrop image. After you follow along the first time, you'll easily be able to swap out the background image with any other image, without having to start over.

STEP ONE: Press Command-N (PC: Ctrl-N) and create a new document measuring 1350 pixels wide by 2000 pixels tall. Then, press Shift-Delete (PC: Shift-Backspace) to open the Fill dialog and set the Contents to 50% gray. Press Command-R (PC: Ctrl-R) to reveal the rulers, and then drag out a vertical guide to the 400-pixel mark, another to the 950-pixel mark, and then a horizontal one to the 1500-pixel mark.

STEP TWO: Now, grab the Rectangular Marquee tool (M) and draw a vertical selection to the left of the first vertical guide. Make it the full height of the document and around 35 pixels wide (just keep an eye on the tool tip that appears when you're dragging). Click on the Create a New Layer icon to put this on a new layer, then press D, then Option-Delete (PC: Alt-Backspace) to fill the selection with black. While it's still selected, press Command-Option-Shift (PC: Ctrl-Alt-Shift) and click-and-drag a duplicate of it to the right side of the second vertical guide. Finally, create a selection along the bottom of the horizontal guide, the same thickness as the previous selections, and fill this one with black, as well. Press Command-D (PC: Ctrl-D) to Deselect.

STEP THREE: Press Command-O (PC: Ctrl-O) and open the background image. Here, we have a typical New York skyline backdrop (which you can download from the book's companion webpage, mentioned in the book's introduction). Using the Move Tool (V), drag-and-drop it onto the working background and place it below the black bar layer in the Layers panel. Press Command-T (PC: Ctrl-T) to activate Free Transform, and then scale and position it however you want. When done, press Return (PC: Enter) and drop the layer's Opacity to 75%.

Step 4

Step 5

STEP FOUR: We'll want to hide the excess image appearing beneath the horizontal line, so add a rectangular selection to the entire area beneath the guide. Then, Option-click (PC: Alt-click) on the Add Layer Mask icon to hide the excess.

STEP FIVE: Make a duplicate of the city layer by pressing Command-J (PC: Ctrl-J), then click on the chain icon between the image thumbnail and layer mask on the duplicate layer to unlink them. Now, go under the Edit menu, under Transform, and choose Flip Vertical. Then, click on the layer mask, so it's active, and press Command-I (PC: Ctrl-I) to Invert it.

STEP SIX: Click back on the duplicate city layer's image thumbnail to make it active and drop its layer Opacity to 10%. With the Move tool, press-and-hold the Shift key and drag the image down to where the top of the buildings are showing as a reflection on the fake floor.

STEP SEVEN: Now, open the main subject image. The subject, here, is at the right stance and perspective for the scene. Since the background is pure white, just grab the Magic Wand tool (Shift-W) and set the Tolerance, in the Options Bar, to 10. Then, click on the background to select it. Don't forget to Shift-click to add the areas between his thumbs and fingers to the selection. Go under Select menu and choose Inverse to flip the selection, and then press Command-J (PC: Ctrl-J) to copy the selected subject to a new layer.

STEP EIGHT: Once extracted, drag-and-drop him onto the main image (make sure this layer is at the top of the layer stack), and then use Free Transform to scale him to fit in the scene, like you see here (press-and-hold the Shift key to keep things proportional). Press Return (PC: Enter) when done. To get rid of any white fringe around him, go under the Layer menu, under Matting, and choose Defringe. Enter around 2 pixels and click OK.

STEP NINE: Make a duplicate of the subject layer, and then position it below the original subject layer in the layer stack. Go under the Edit menu, under Transform, and choose Flip Vertical, and then press-and-hold the Shift key and drag this duplicate down to where the reflection of his legs and feet looks real. Click on the Add Layer Mask icon at the bottom of the Layers panel, and then get the Gradient tool (G). In the Options Bar, click on the gradient thumbnail and choose the Foreground to Transparent gradient, click on the Linear Gradient icon (to the right of the gradient thumbnail), set the Opacity to around 75%, and then (with your Foreground color set to black) add a subtle fade from the bottom of the image.

Step 10

Step 11

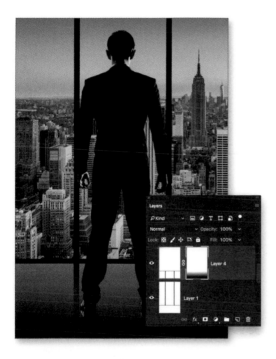

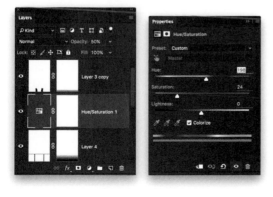

STEP 10: Select the gray Background layer in the Layers panel, then set the Gradient tool's Opacity back to 100%, and add small black gradients to the top and bottom of the layer.

STEP 11: Now, select the black bars layer in the Layers panel, and use the Rectangular Marquee tool to draw a selection over the entire floor area and lower half of the horizontal black bar (as shown above). Press Command-Shift-J (PC: Ctrl-Shift-J) to cut this area to a new layer (if you see a visible line now, after making this cut, just use the Move tool to move this cut layer up a little). Now, add a layer mask to this layer, and then add a black linear gradient to the bottom of it to give the window frame reflection a fade.

STEP 12: Click on the Create New Adjustment Layer icon at the bottom of the Layers panel and choose Hue/Saturation. Make sure this layer is positioned below the subject layers, but above the background layers, in the layer stack. In the Properties panel, turn on the Colorize checkbox, set the Saturation to around 25 and the Hue to around 200. When done, drop the layer's Opacity to 50%.

STEP 13: Now, let's add some detail to the highlights in the subject. Click on the main subject layer, and then click on the Lock Transparent Pixels icon near the top of the Layers panel to lock this layer. Grab the Brush tool (B) and choose a simple, soft-edged brush from the Brush Picker in the Options Bar. Set the brush's blend Mode to Overlay, and paint along the edges of the subject to enhance the highlights more.

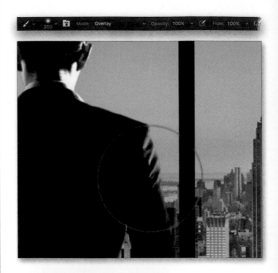

STEP 14: Select the original city background layer, and then go under the Filter menu, under Blur, and choose Gaussian Blur. Give it a 2-pixel blur, click OK, and then do the same thing to the reflected city layer.

STEP 15: Let's add one last atmospheric element. Click on the Create a New Layer icon at the bottom of the Layers panel to create a new blank layer and move it to the top of the layer stack. Get the Gradient tool again, and using the same Foreground-to-Transparent gradient, click on the Radial gradient icon to the right of the gradient thumbnail, then press-and-hold the Option (PC: Alt) key and click in a cool area of the sky to select that color. Then, starting beyond the image boundary in the upper right (drag out your image window), click-and-drag out a gradient in the corner. Drop the layer's Opacity to 75% and set the blend mode to Screen.

Finally, just add some text in (I used Trajan Pro 3 Regular here), and you are all set. You can always change the background image and its reflection to get a whole new scene.

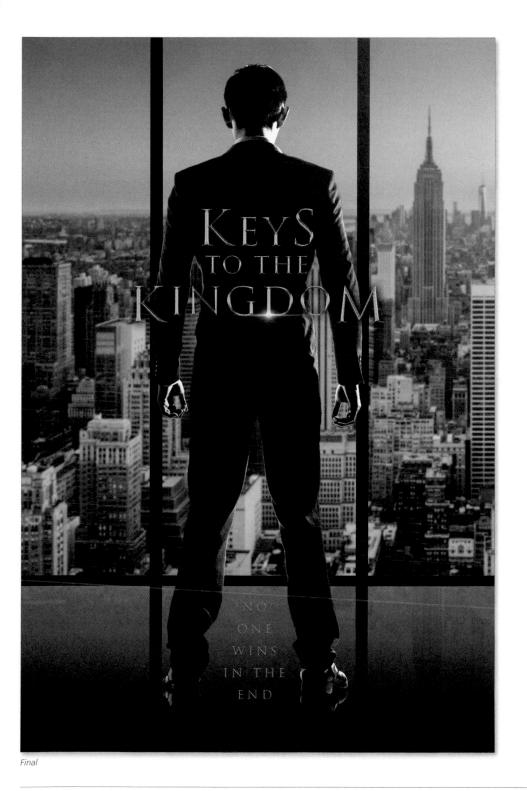

Final

CHAPTER NINE

3D Effects

Like layer styles, 3D in Photoshop has quickly become an integral part of designing in Photoshop. You can achieve a lot more than you think, once you know what you can do. In this chapter, I cover a few condensed techniques that will give you impressive results, even if you have little to no 3D knowledge. It just might make you want to learn more.

We'll start here with a cool macro trick you can do to photos and graphics. You can also do this to text to create that macro look of being really close. So, here, we will use a simple text block, but be sure to experiment with images, as well. This is similar to what we did in the text chapter, but here we will utilize some depth of field.

STEP ONE: Press Command-N (PC: Ctrl-N) and create a new document measuring 2500 pixels wide by 1200 pixels tall, with the Background Contents set to White. Then, select the Horizontal Type tool (T) and click-and-drag to create a text box the exact size of the document—start at the top-left corner and drag to the bottom-right corner.

STEP TWO: In the Options Bar, set the font size to 35 pt, and choose a font—here, I am using Times Regular. In the Paragraph panel, (Window>Paragraph), click on the Justify All icon at the top right. Then, go under the Type menu and choose Paste Lorem Ipsum. This will place filler text. (Of course, if you have your own text you want to use, then go ahead and use that.) Now, this will only paste a paragraph of text, so go under the Type menu, again, and choose Paste Lorem Ipsum a few more times to fill the box.

STEP THREE: Highlight a small area of text and then type in a word or message you want to emphasize. Here, I set STAND OUT in all caps and filled it with red—just click on the color swatch in the Options Bar when the text is highlighted and choose a color from the Color Picker.

STEP FOUR: Now, click on the Move tool in the Toolbox, then go under the 3D menu, under New Mesh from Layer, and choose Postcard. This will put the flat 2D layer in 3D space. In the Layers panel, double-click on the Lorem Ipsum sublayer, under the Diffuse texture, and then click OK in the resulting dialog to open the original text file. Command-click (PC: Ctrl-click) on the Create a New Layer icon at the bottom of the Layers panel to create a new blank layer below the text layer, and then press Shift-Delete (PC: Shift-Back-space) to open the Fill dialog. Choose White from the Contents pop-up menu, and then press OK to fill the new layer with white. Notice you can edit the text if you want here, as well. When done, close this type image and save the changes.

STEP FIVE: In the 3D panel, select Current View, then in the Properties panel, drop the FOV (Field of View) setting to 10mm lens. This will give you a wider scope lens, so you can get really close. Also, set the Depth to 7. This will make the image look blurry for the moment. Now, select the Background layer in the Layers panel, press Shift-Delete (PC: Shift-Backspace) to open the Fill dialog, and choose Black from the Contents pop-up menu to fill it with black.

STEP SIX: Make sure the Move tool is still se-lected, click back on the 3D layer, and then use the 3D Mode tools at the right end of the Options Bar to manipulate the postcard in 3D space. These tools do take some time to get used to if you have never used them before, so be patient and play with them for a while to get better acquainted with how they work. Here, I used the Orbit, Pan, and Slide tools and positioned the text at an extreme angle with the red text in view. Once in place, press-and-hold the Option (PC: Alt) key, and you'll see a small target icon appear in place of the cursor. This allows you to set the focal point. So, just click on the image where you want it to be in-focus. Try it all over to see the different results. (*Note:* It's still fuzzy because it needs to be rendered.)

STEP SEVEN: Go back to the 3D panel and click on the Filter By: Lights icon (the light bulb icon at the top of the panel), and then make sure Environment is selected in the list below. Over in the Properties panel, turn off the IBL (Image Based Light) checkbox. This will basically turn the lights off and make it dark. Go back to the 3D panel, click on the Add New Light to Scene icon (the light bulb icon) at the bottom of the panel, and choose New Point Light. Then, back in the Properties panel, click on the Move to View icon to bring the light up front. Now, use the 3D Mode tools again to position the light just above the text like you see here. The light bulb icon near the top right, here, indicates where the light is outside the window.

STEP EIGHT: Once the light is in place and the focal point is set, go ahead and render the image by going under the 3D menu and choosing Render 3D Layer. If you need to make any adjustments, you can stop the render at any time by pressing the Esc key.

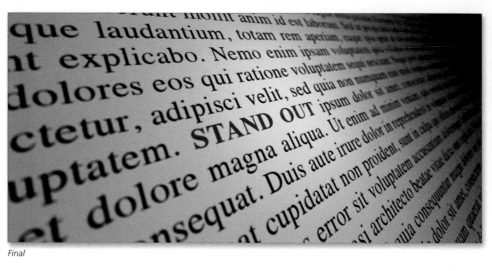

Final

©ADOBE STOCK/MEXRIX

Here is another quick and easy way to add 3D to your design without a lot of 3D training. All you need is a texture and a little text.

STEP ONE: Press Command-O (PC: Ctrl-O) and open the texture image you want to use or open the one I'm using here (you can download it from the book's companion webpage, mentioned in the book's introduction). Grab the Horizontal Type tool (T), set a text layer, and then input some text. A nice thick font will work best, but be sure to try different ones. Here, I am using Futura Extra Bold and set the word METAL in all caps at around 100 pt. For the color, click on the color swatch in the Options Bar, and then just click to sample a light gray from the background to fill the text with.

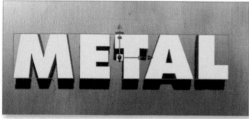

STEP TWO: Once the text is set, click on the Move tool in the Toolbox, then go under the 3D menu and choose New 3D Extrusion from Selected Layer. This will extrude the text. (*Note:* I turned off the default 3D Ground Plane here, by going under the View menu, and choosing it under Show.)

STEP THREE: Now, select the texture layer in the Layers panel and press Command-J (PC: Ctrl-J) to make a duplicate, and then go under 3D menu again, under New Mesh from Layer, and choose Postcard. We need to merge these two 3D objects together, but when you merge one layer with another, it assumes the properties of the bottom layer. So, in order to keep the lighting of the text, click-and-drag the texture postcard layer above the text layer in the layer stack, then press Command-E (PC: Ctrl-E) to merge it down.

STEP FOUR: In the 3D panel, select Environment. Then, in the Properties panel, set the IBL Intensity slider to 50%.

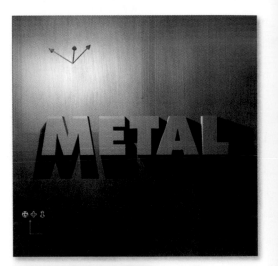

STEP FIVE: At the top of the 3D panel, click on the Filter By: Lights icon (it looks like a light bulb), and select the default Infinite Light. Then, go to the Properties panel, choose Point from the Type menu, and click on the Move to View icon. Also, set the Intensity to around 100% and the Softness to 50%. Now, use the 3D Mode tools, at the right end of the Options Bar, to position the light just above and to the left of the text (here, I used the Drag and Pan tools). You can see the shadow move as you move the light.

Final

We all know that you can bevel text in Photoshop using layer styles, but that is just an illusion of a beveled edge. With three simple 3D tricks, you can achieve actual beveled-edged text and graphics. You can also light it and add texture in very dramatic ways.

STEP ONE: Begin by pressing Command-O (PC: Ctrl-O) and opening the start file for this exercise (which you can download from the book's companion webpage, mentioned in the book's introduction). I have already formatted the text in in a font called Mauritius Bold, which is part of Typekit. You should have this font, but if not, in the font menu in the Options Bar, click on the Typekit icon on the far right to open Typekit and search for it, or you can replace it with something close. Here, I have the fictional title *The Beast of Burden*. (No, I am not that big a Stones fan.)

STEP TWO: With the text layer selected, go under the 3D menu and choose New 3D Extrusion from Selected Layer. This will put a large extrusion on the text, but we do not need any extrusion at all in this case. (*Note:* I turned off the default 3D Ground Plane here, by going under the View menu, and choosing it under Show.)

STEP THREE: So, go to the 3D panel and select the main text layer item in the list. Then, go to the Properties panel and set the Extrusion Depth to 1 px.

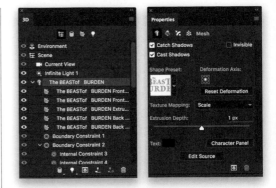

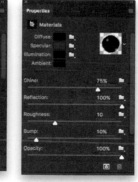

STEP FOUR: Next, select Environment at the top of the list in the 3D panel. Then, in the Ground Plane section in the Properties panel, set the Shadows Opacity to 1%.

STEP FIVE: Click back on the main text layer item in the 3D panel, then click on the Cap icon at the top of the Properties panel (it's the third one from the left). Under Bevel, set the Width to 100%.

STEP SIX: Now, go back to 3D panel and select The Beast of Burden Front Bevel Material. In the Properties panel, set the Shine to 75% and the Reflection to 100%. Also, set the Roughness to 10 to soften the reflection. At this point, you should see the default IBL (Image Based Light) reflected in the text.

STEP SEVEN: Next, open the abstract chrome texture. Press Command-A (PC: Ctrl-A) to select the entire image, and then copy it to the clipboard by pressing Command-C (PC: Ctrl-C). Go back to our main image and replace the default IBL by selecting Environment in the 3D panel, then clicking on the icon to the right of the IBL preview in the Properties panel and choosing New Texture from the pop-up menu. Go ahead and click OK when the New dialog appears, then go back into the IBL pop-up menu and choose Edit Texture. When the IBL image window opens, press Command-V (PC: Ctrl-V) to paste the chrome texture image into it. Then, just close the document and save the changes. Also, drop the IBL Intensity setting to 75% and set the Shadows Opacity to around 1%.

STEP EIGHT: You'll now see a ghost image in the background and a small sphere in the center. These are just visual aids to help you position the IBL—think of it as a translucent ball around the text. You can use the 3D Mode tools, at the right end of the Options Bar, to move the IBL around to get a different look on the text surface.

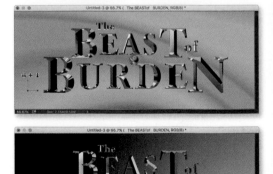

STEP NINE: Now, let's add some imperfections to this. Here, we have a simple stone texture image. Start by removing the color by pressing Command-Shift-U (PC: Ctrl-Shift-U). Make a duplicate of the Background layer by pressing Command-J (Ctrl-J), and then change the duplicate's blend mode to Screen. Make a couple more duplicates to lighten the background more, and then flatten the image back down to one layer by choosing Flatten Image from the Layers panel's flyout menu. Finally, select the image, and then copy it to the clipboard like we did before.

STEP 10: Back in our main image, go to the 3D panel and select The Beast of Burden Front Bevel Material, again. Then, in the Properties panel, go to the Bump setting, click on the folder icon to its right, and choose New Texture from the pop-up menu. Photoshop should remember the dimensions of the stone texture image in the clipboard, so just click OK. When the document opens, paste the stone texture in this canvas, then close the document and save the changes. You will immediately see the little dings in the chrome.

STEP 11: You can adjust this texture's position by going back into the Bump pop-up menu and choosing Edit UV Properties. Now, I prefer to use the scrubby sliders in the Texture Properties dialog, by placing my cursor over a setting name, and then clicking-and-dragging left/right. The change is live, so you can see it on the object. Here, I only adjusted the Scale. Click OK when done, and then decrease the Bump setting to 3%.

STEP 12: Back in the 3D panel, select the default Infinite Light near the top of the list. In the Properties panel, go to the Type menu, and choose Point to change it. Then, click on the Color swatch just below, choose a goldish yellow color from the Color Picker, and then boost the Intensity to around 110%. Click on the Move to View icon below to place it in front, then use the 3D Mode tools to reposition it, if needed. (*Note:* You can make your background black, like I did here, by clicking on the Background layer in the Layers panel, pressing Shift-Delete [PC: Shift-Backspace], and then choosing Black from the Contents pop-up menu.)

Now, just choose Render 3D Layer from the 3D menu, and you are pretty much done (or continue on to the bonus tips up next). I just added some small flares (see Chapter 6) as a finishing touch, here.

BONUS TIPS: Now, at this point, you can be done, but I wanted to show you a couple more things to demonstrate the flexibility of 3D in Photoshop.

TIP #1: Say you want the text to be gold, rather than silver. Well, click on Environment in the 3D panel, then choose Edit Texture from the IBL pop-up menu to open the IBL image of the abstract chrome. Click on the Add New Adjustment Layer icon at the bottom of the Layers panel and choose Hue/Saturation. In the Properties panel, turn on the Colorize checkbox, then set the Hue to around 35 and the Saturation to around 50. Close the IBL image and save the changes. Voila! Gold text.

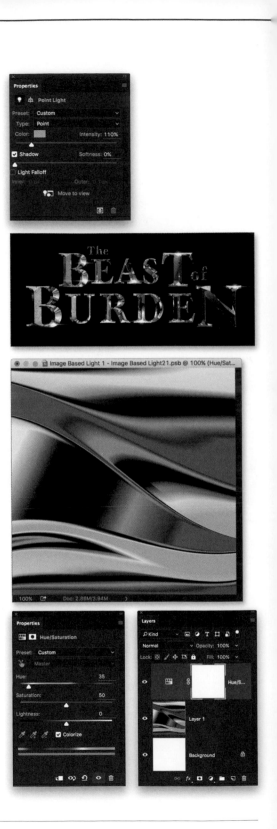

TIP #2: Also, say you wanted to adjust the font or even change the text itself. Go to the 3D panel and choose the main text item in the list. At the bottom of the Properties panel, click on the Edit Source button to open the original text file. Now, you can make whatever changes you want. Here, I made the font regular instead of bold and eliminated the word "The." Just close and save the changes, and your text is updated with all the 3D effects still intact. You may need to make a few minor tweaks, depending on the changes that you make, but it's much better than starting all over again.

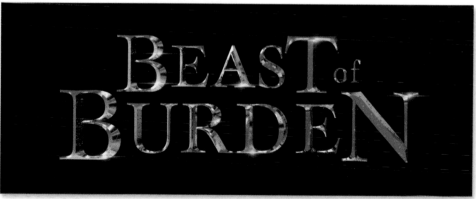

Final

INDEX

INDEX

INDEX